Making
Pipe Cleaner Pets

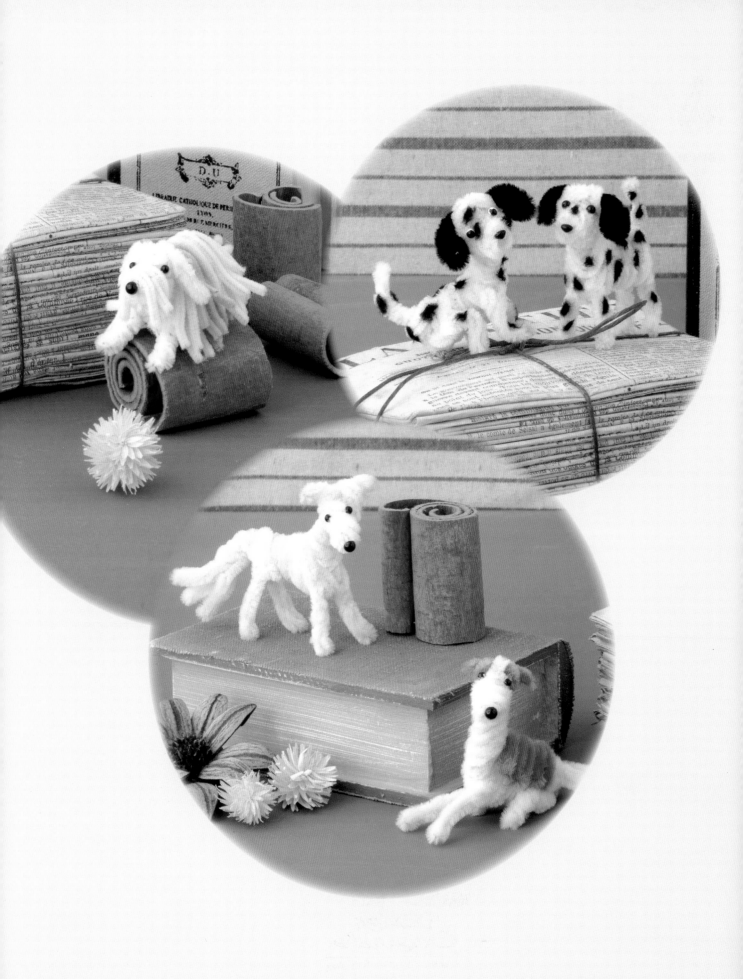

Making
Pipe Cleaner
Pets

Design Originals

an Imprint of Fox Chapel Publishing

www.d-originals.com

Lady Boutique Series No. 3332 モールでつくるちいさな犬たち
Copyright © 2012 Boutique-sha, Inc.
All rights reserved.
Originally published in Japan by Boutique-sha, Inc.
North America English translation copyright © 2013 New Design Originals Corporation, an imprint of Fox Chapel Publishing
Arranged with Boutique-sha, Inc. through LEE's Literary Agency, Taiwan

Credits for the Japanese Edition
Production & Instructions: Harinezumi Kobo (Takashi Morito, Shino Morito, Atsushi Morito)
Photography: Minoru Suwa
Display Coordinator: Ayako Ishizuka
Layout: Ad Balloon, Harinezumi Kobo
Illustrations: Takashi Morito
Tracing: Yuji Sekiguchi
Editing and Planning: Ad Balloon, Harinezumi Kobo
Editing Assistance: Masaya Ikeda (DEGICO inc.)
Koji Ishihara, (Ishihara Mokei Kobo, Kenta Ueoka)
Shigenori Maruyama (T-brain)

Credits for the English Edition
Publisher: Carole Giagnocavo
Acquisition Editor: Peg Couch
Editor: Colleen Dorsey
Designer: Ashley Millhouse

ISBN 978-1-57421-510-6

Making Pipe Cleaner Pets is an unabridged translation of the original Japanese book, with additional content. This version published by Design Originals, an imprint of Fox Chapel Publishing Company, Inc., 1970 Broad Street, East Petersburg, PA 17520.

Library of Congress Cataloging-in-Publication Data

Moru de tsukuru chiisana inutachi. English.
 Making pipe cleaner pets.
 pages cm
 Includes index.
 Summary: "Presents instructions for making 23 different breeds of dogs out of pipe cleaners (chenille stems) using just glue, a few small accessories, and simple wrapping and bending techniques"-- Provided by publisher.
 ISBN 978-1-57421-510-6 (pbk.)
 1. Pipe cleaner craft. 2. Dogs in art. I. Title.
 TT880.M68613 2013
 745.592--dc23
 2013017298

Printed in China
Second printing

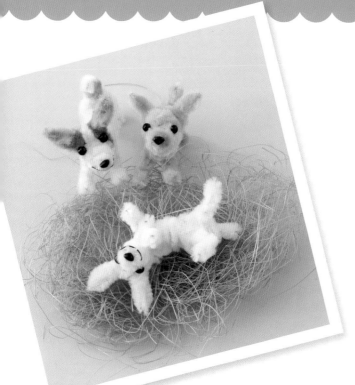

Publisher's Note

As a Publisher of craft books, I enjoy the opportunity to review many different book ideas every year. Sometimes book concepts come from our editors in-house. Other book titles are published at the request of our customers.

Every so often an idea comes along that is simply too wonderful to pass up. Such is the case with *Making Pipe Cleaner Pets*. I can honestly say that in the many hundreds of book concepts we've explored over the years, this is definitely the first time we've seen this sort of thing. Admittedly, never once had any of us ever thought "We need a book on making small dogs out of pipe cleaners!" either.

However, when this book arrived at our office in its original Japanese format, we were smitten! The book was just too adorable to ignore. We showed it to our editors; they laughed. We showed it to our sales group; they laughed. We showed it to customers; they laughed! It brought a feeling of joy to each person who looked at it, and we thought that was a good enough reason to publish it.

This book, originally published by Boutique-Sha in Japan, encompasses everything we love about the Japanese craft aesthetic. It is unexpected and charming without ever compromising on craftsmanship and quality. It has an inexplicable feeling of happiness and joy. It is for this reason that Design Originals is dedicated to translating and publishing hand-picked Japanese craft books for the English-language market. Whether quilting, sewing, or general crafts, we have many more translated titles in development and are always looking for the most special selections to acquire for you.

We hope that as you work your way through the projects in this book, you will also be inspired by simple designs and sheer pleasure of bringing each pipe cleaner pet to life. As always, we appreciate your readership and would love to hear from you. Please visit us at *www.d-originals.com* to see all we have to offer.

Happy Crafting,

Carole

Carole Giagnocavo
Publisher
Design Originals
carole@d-originals.com

CONTENTS

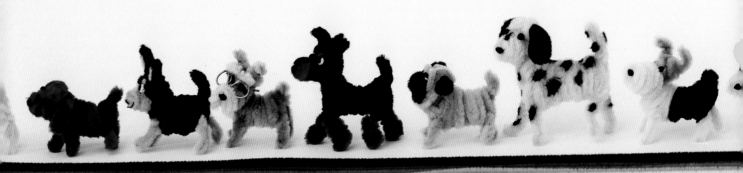

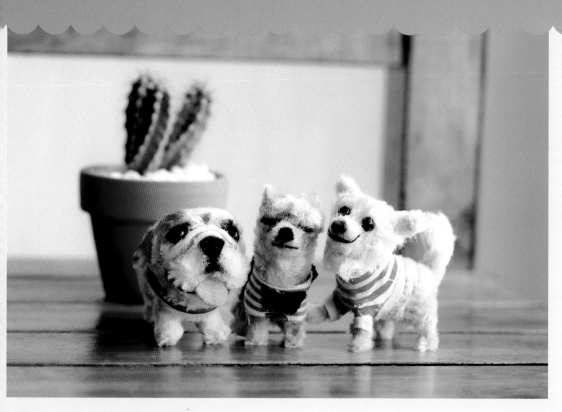

Author's Note
(translated from Japanese)

To have a little workshop with a herb garden... that's my family's dream.

We make dolls out of pipe cleaners and felt, and we make picture books and clothing too. Together we are Hedgehog Workshop! You'll see us all as little hedgehogs guiding you throughout the book.

When I was sick and I couldn't move, another member of our family stayed by my side, our lovely dog Tiara. She was so cute that I used the pipe cleaners my daughter had been playing with and made a little doggy. This was the start of my pipe cleaner journey. To use my hands and get absorbed in something helps me to keep a positive state of mind. The light, fluffy texture of pipe cleaners makes my heart feel light too. The way they can change shape so freely sets my heart free as well.

Won't you all join me to make your own beloved family member or friend out of pipe cleaners?

ABOUT THE AUTHOR
TAKASHI MORITO (PAPA HEDGEHOG)

Papa Hedgehog is an artist who began making self-taught pipe cleaner art in 2009. Currently he holds exhibitions of original works, offers workshops for parents and children, creates pipe cleaner dog craft kits, and fills his time with other activities at his own pace. You can visit his Japanese website at: http://ameblo.jp/harinezumi-s/

If you can't find 40" (1m) pipe cleaners, you can make them by twisting together four or five shorter pipe cleaners. Please be careful not to hurt yourself on the ends of the wires.

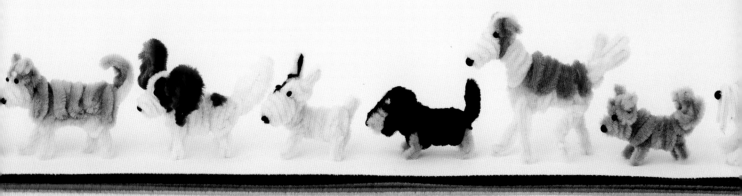

Toy Poodle

How to make models 1–7: page 36

One has a pointed head,
Another takes a nap
They're all different
That's what makes it fun!

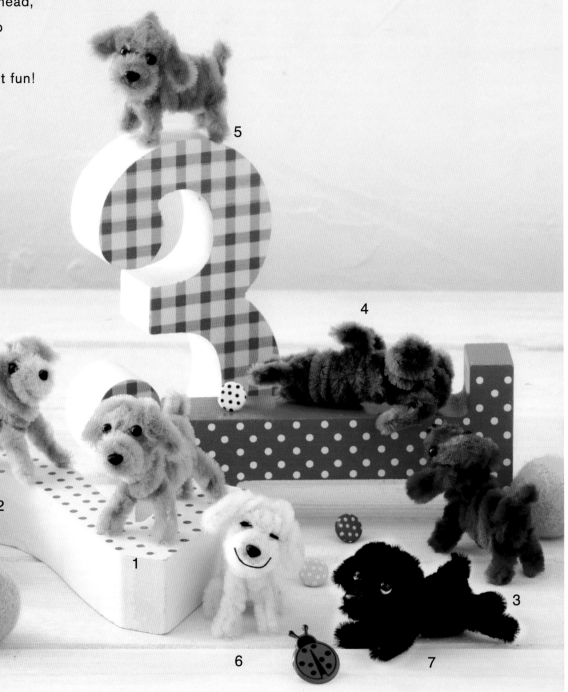

Making Pipe Cleaner Pets

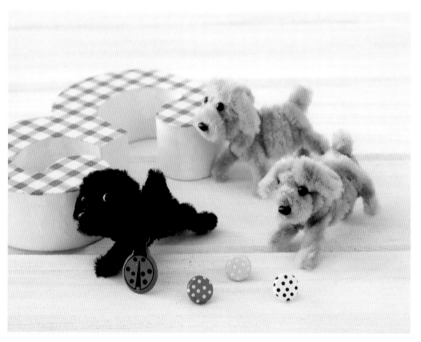

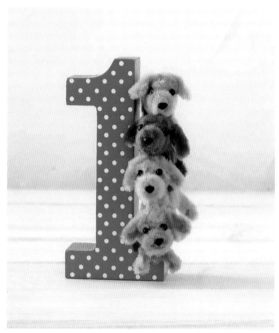

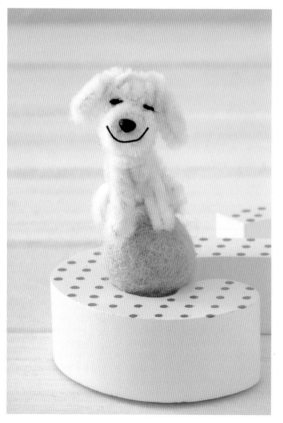

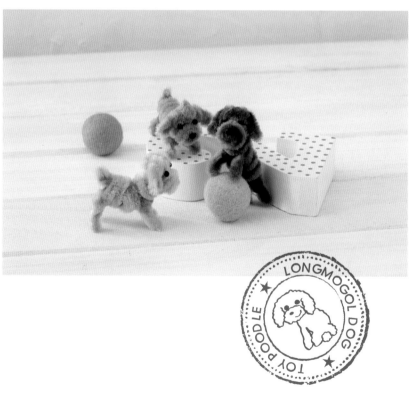

Chihuahua

How to make models 8, 10: page 50
How to make models 9, 11, 12: page 48

Hey, why are you showing your tummy?

Oh, I'm looking at the sky

Sometimes I like to look up at the sky

And breathe deeply

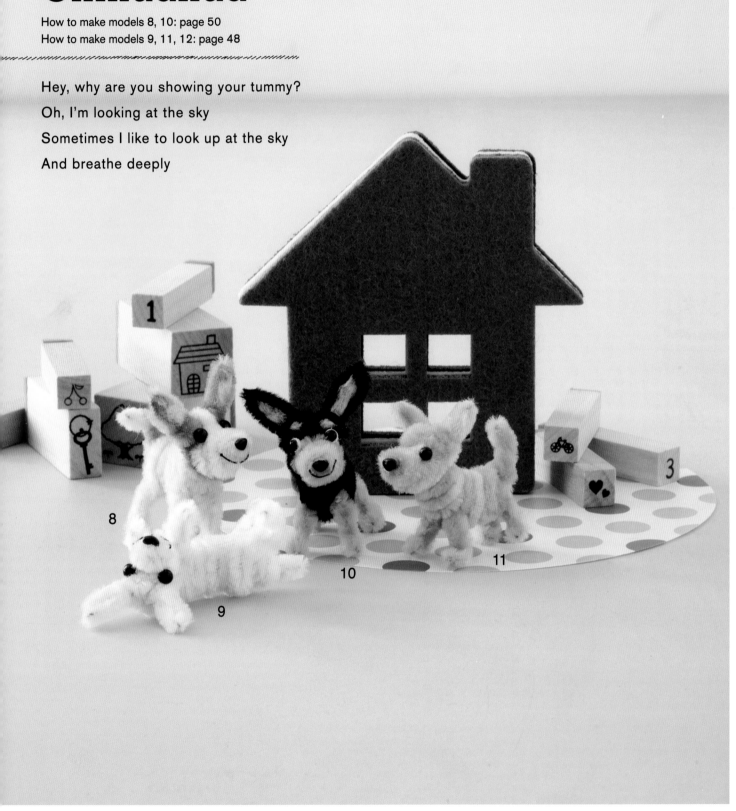

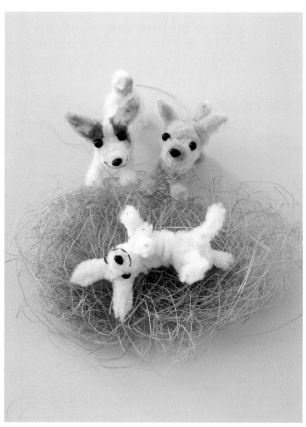

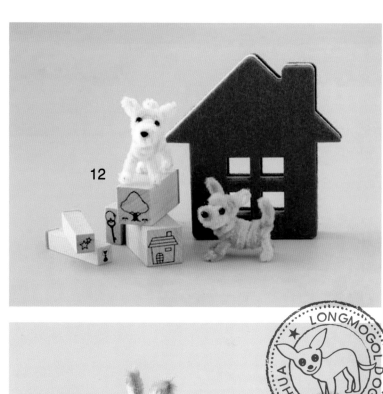

12

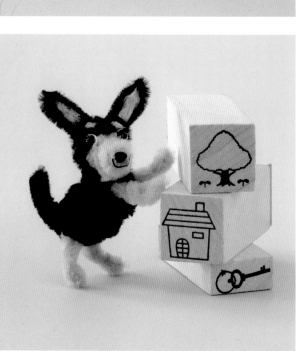

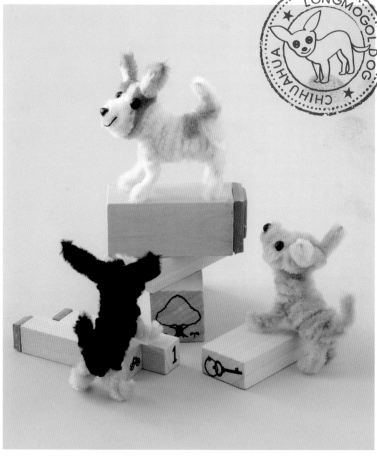

Making Pipe Cleaner Pets

Miniature Schnauzer

How to make models 13–16: page 52

Sometimes I like to quietly

Read a book

That book might just

Save your life

Someday

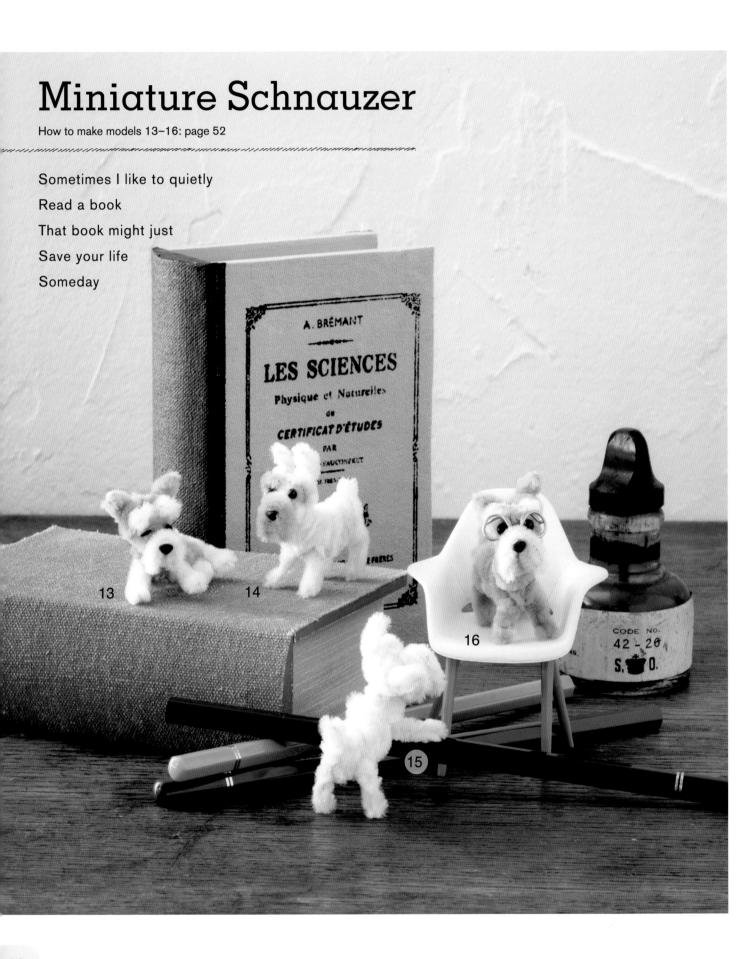

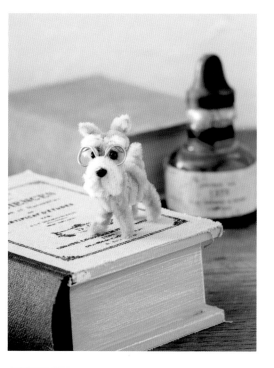

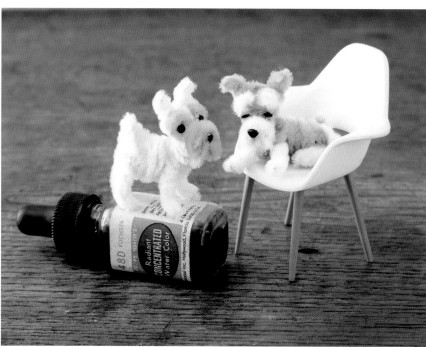

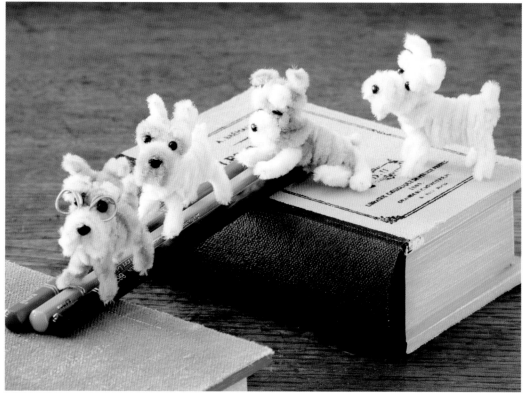

Making Pipe Cleaner Pets

Boston Terrier

How to make model 17: page 84
How to make models 18–20: page 43

No matter how rough the road,

As long as you've got family

It will be all right

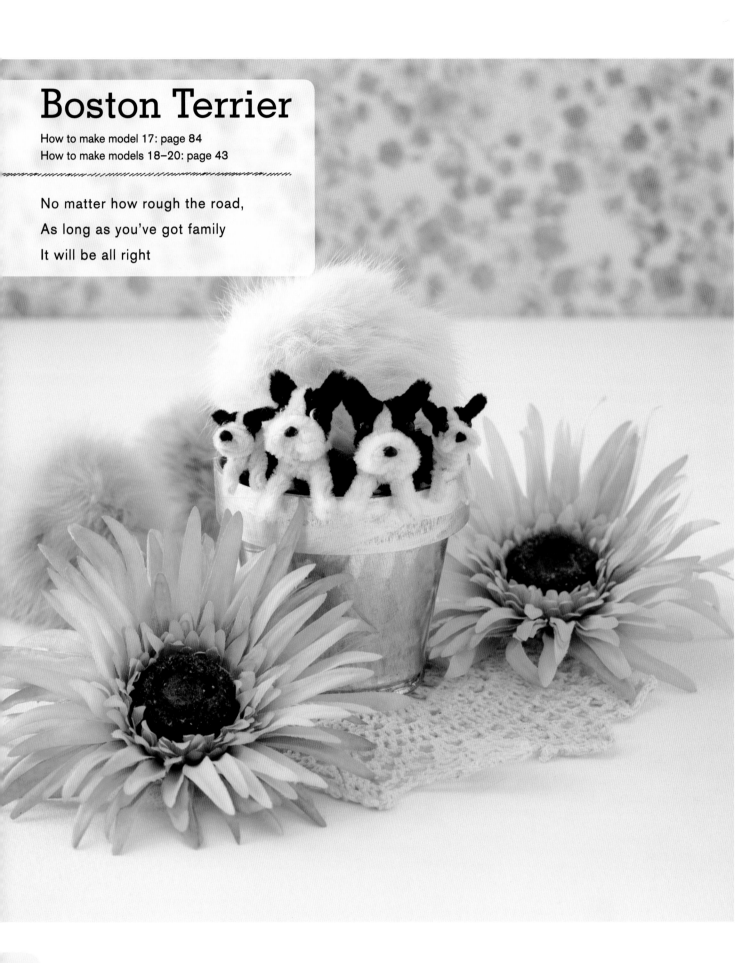

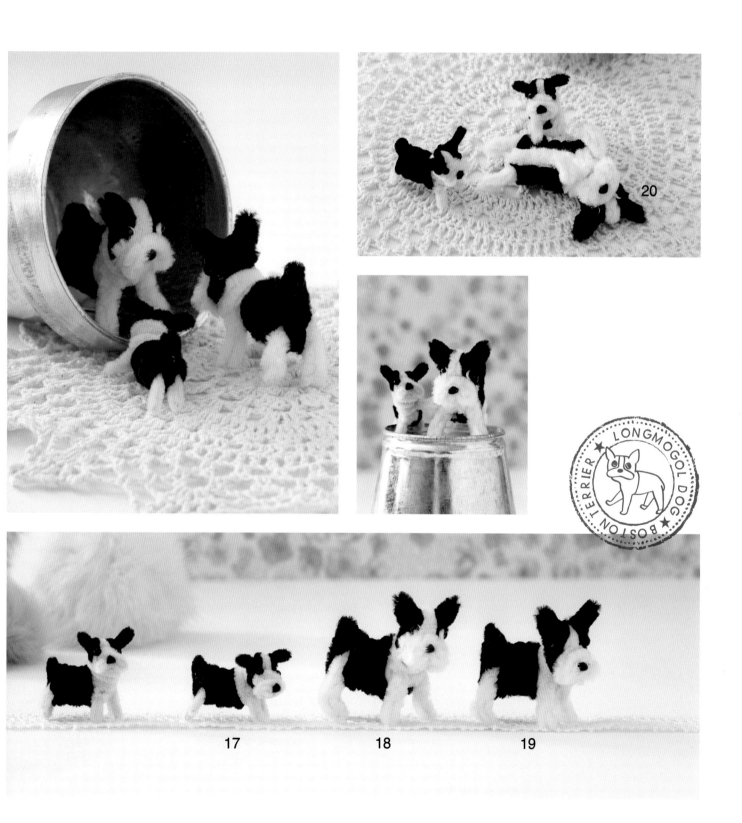

17 18 19

Making Pipe Cleaner Pets

Cavalier King Charles Spaniel

How to make models 21, 23, 24, 25: page 54
How to make model 22: page 55

Now we're going to build blocks

Stack them up one by one

We'll build our dreams

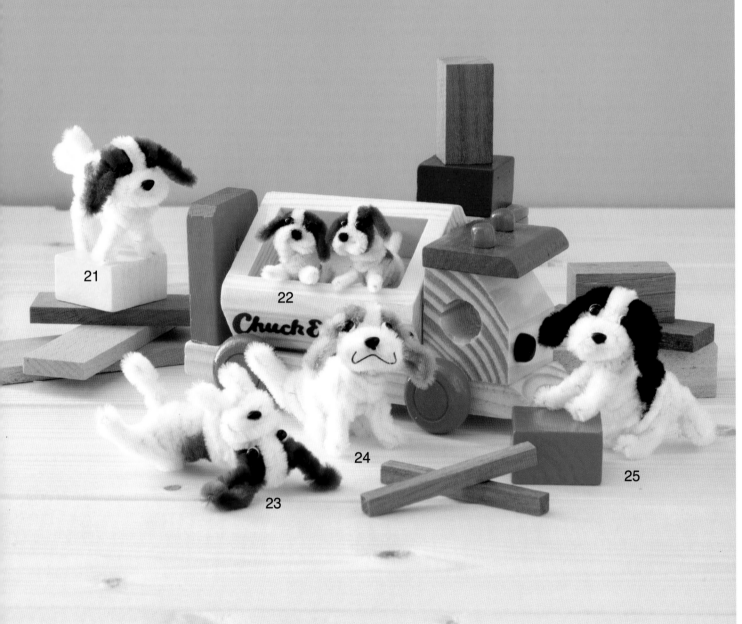

Making Pipe Cleaner Pets

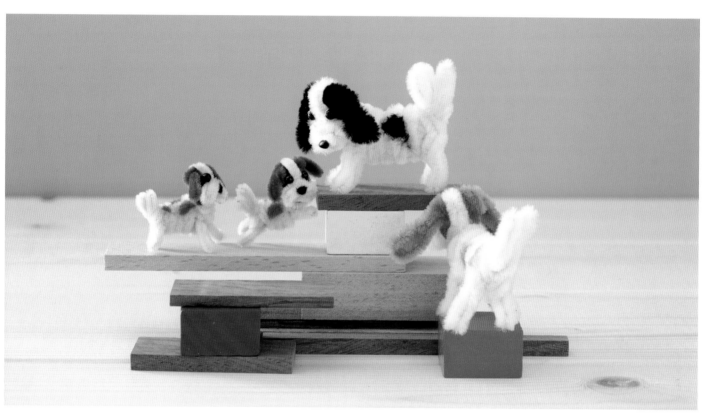

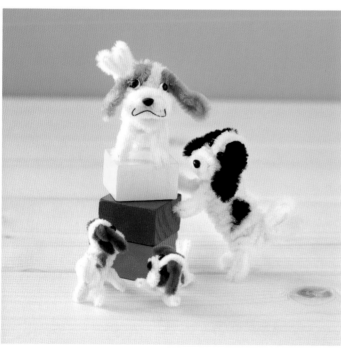

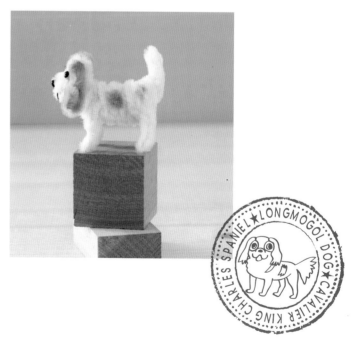

Making Pipe Cleaner Pets

Miniature Dachshund

How to make models 26, 29, 32: page 58
How to make models 27, 28, 30: page 56
How to make model 31: page 57

There are many different ways to live

But you can live in your own way

That's the most comfortable

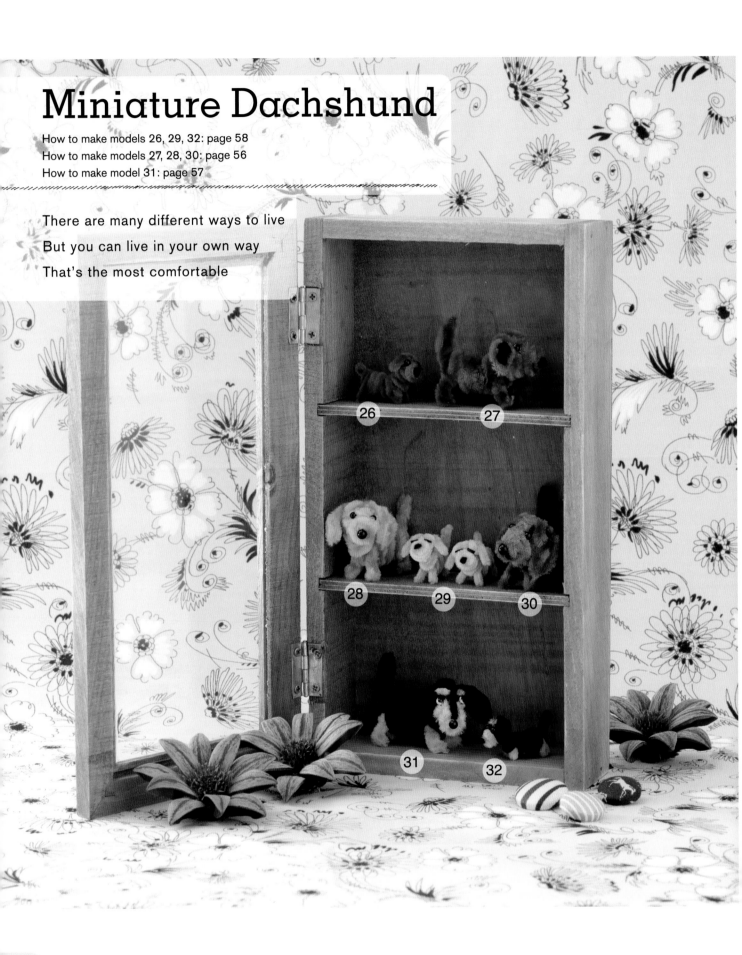

Making Pipe Cleaner Pets

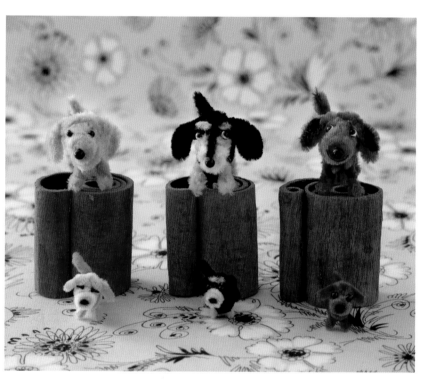

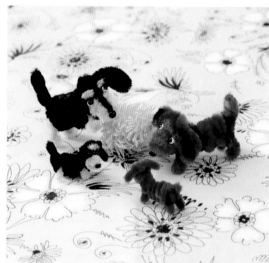

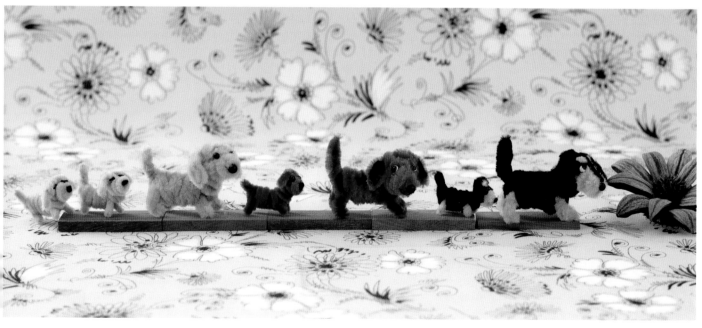

Pug

How to make models 33, 34, 37, 38: page 40
How to make models 35, 36: page 83

You're so fluffy

The warmth I get from holding you

Says "It's OK, it's OK"

And makes me feel better

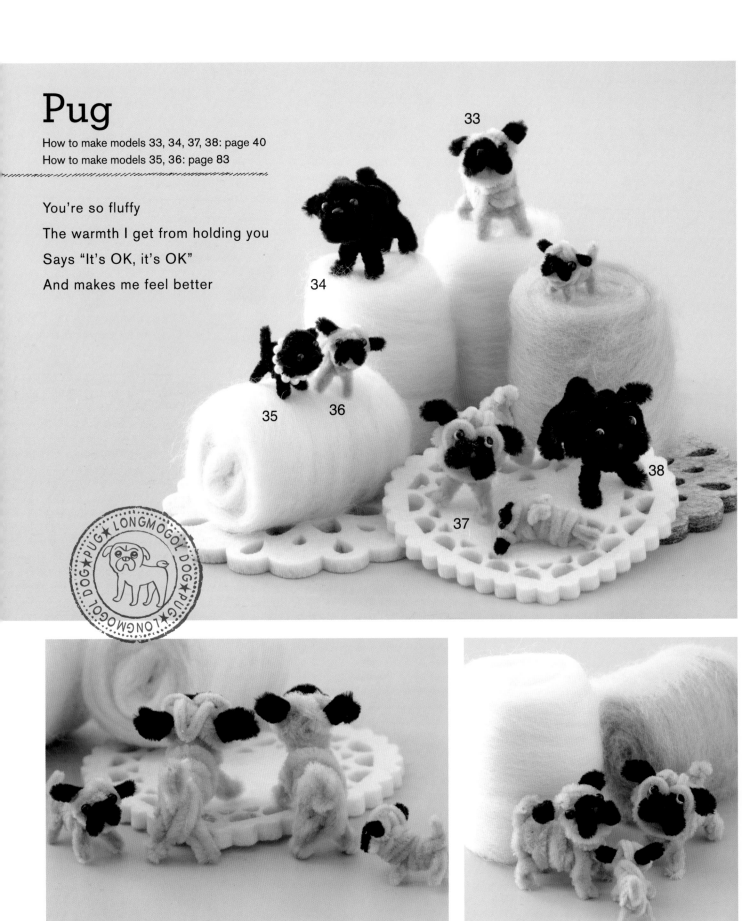

Making Pipe Cleaner Pets

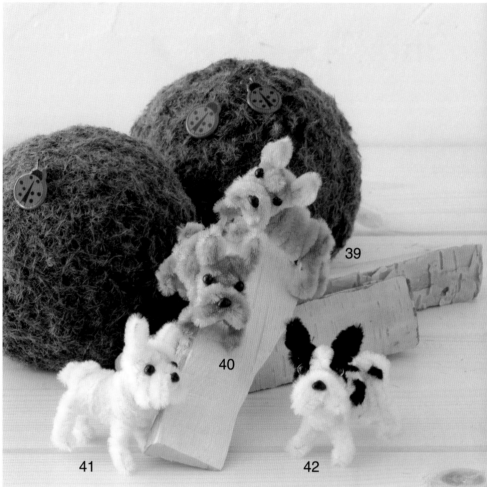

39

40

41

42

French Bulldog

How to make models 39–42: page 60

Let's climb this mountain

We'll climb it together

Then we'll surely see

A new tomorrow

Shih Tzu

How to make models 43–45: page 62

So cute
That you could eat me up,
you say?

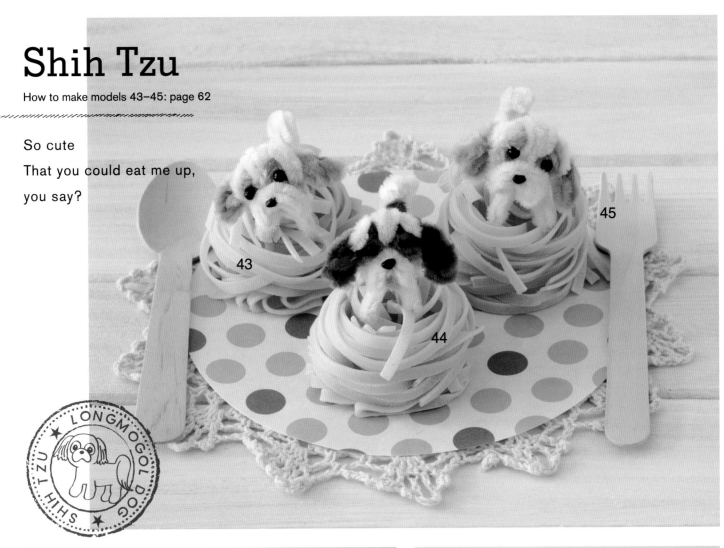

43

44

45

SHIH TZU ★ LONGMOGOLDOG ★

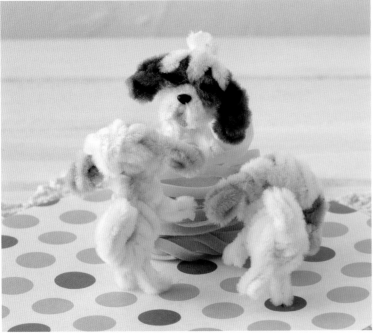

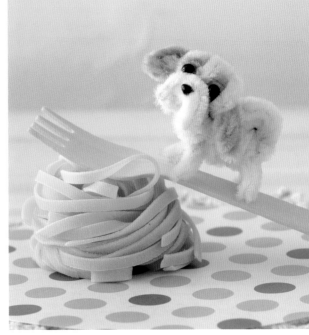

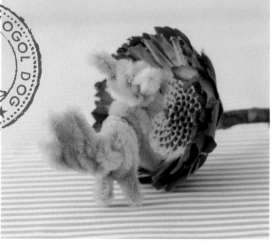

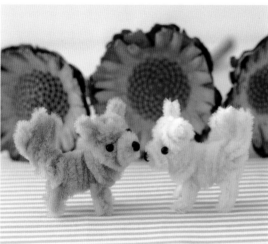

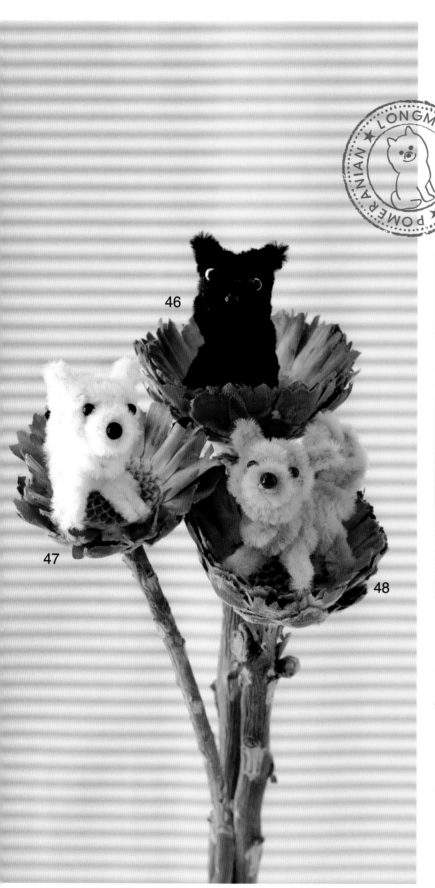

46

47

48

Pomeranian

How to make models 46–48: page 59

Look, each one of them

Has turned into

A fluffy beautiful flower

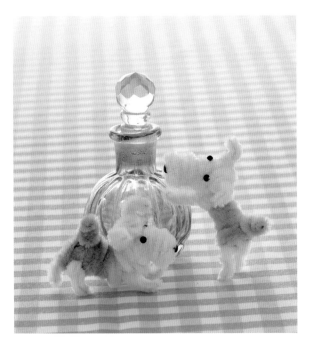

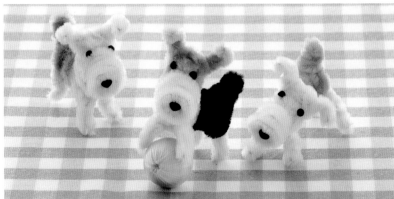

Wire Fox Terrier

How to make models 49, 51: page 64
How to make model 50: page 65

The morning air feels good

Now, we'll all play ball

And bathe in the morning sun

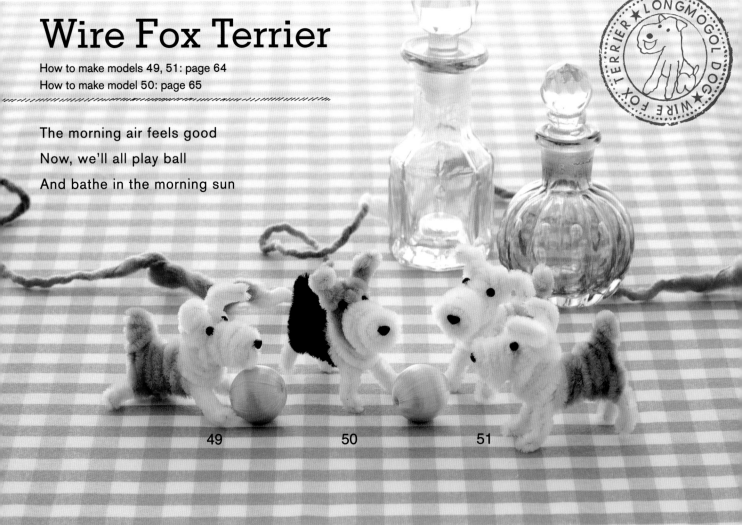

49 50 51

Making Pipe Cleaner Pets

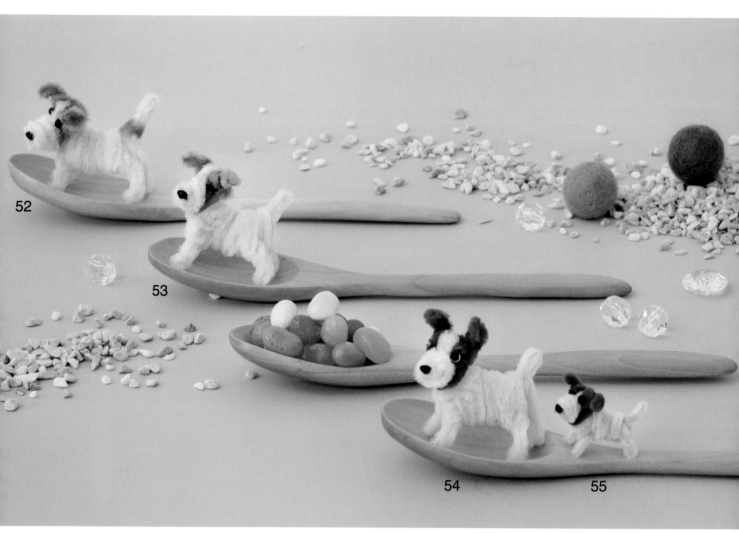

52

53

54 55

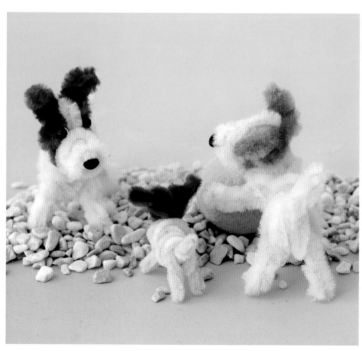

Jack Russell Terrier

How to make models 52–54: page 66
How to make model 55: page 67

Give me a spoon

And I'm a wave-riding surfer

Up on the wide, wide ocean

All my little worries fly away!

Italian Greyhound

How to make models 56–59: page 68

Sometimes you've got to stretch
Your back, puff out your chest,
And go!
Now, make a pose!

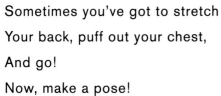

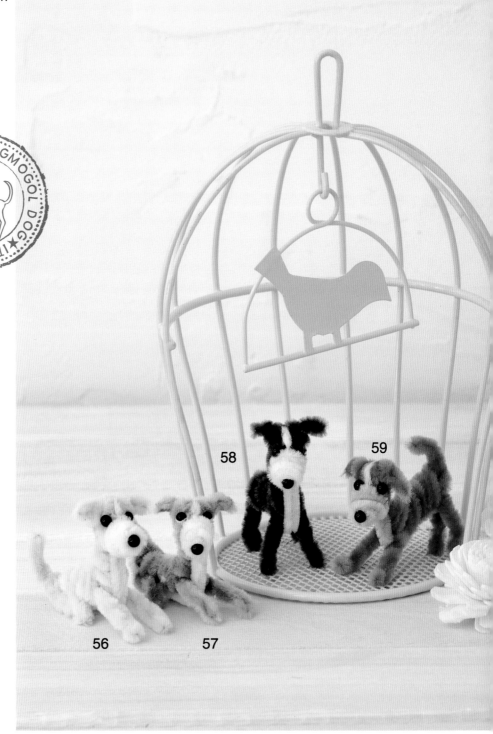

58

59

56

57

Miniature Bull Terrier

How to make models 60, 61: page 51

Did you know?

If you put your dream into words once a day

They say that your words will come true!

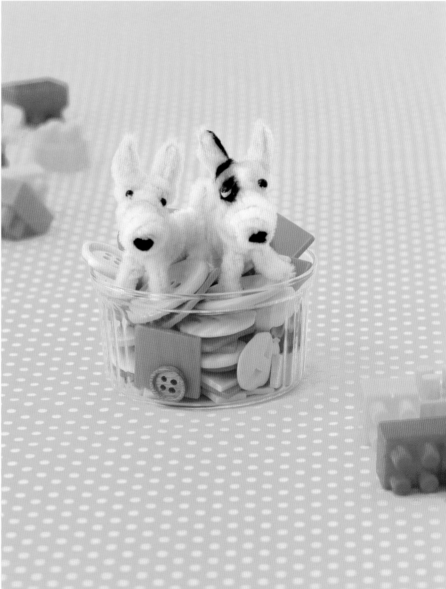

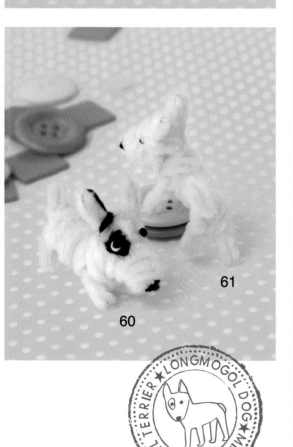

61

60

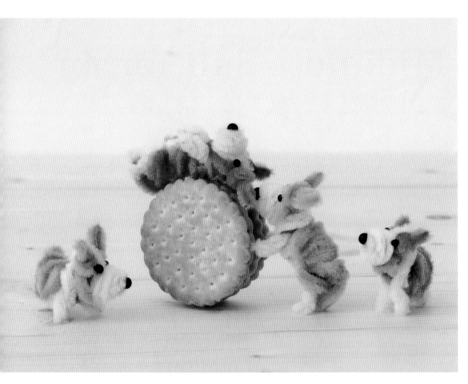

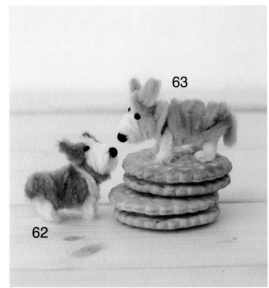

63

62

Pembroke
Welsh Corgi

How to make models 62, 63: page 73

Wow, a mountain of cookies!

Let's climb it together.

Hey, who's that?

Eating one of the cookies!

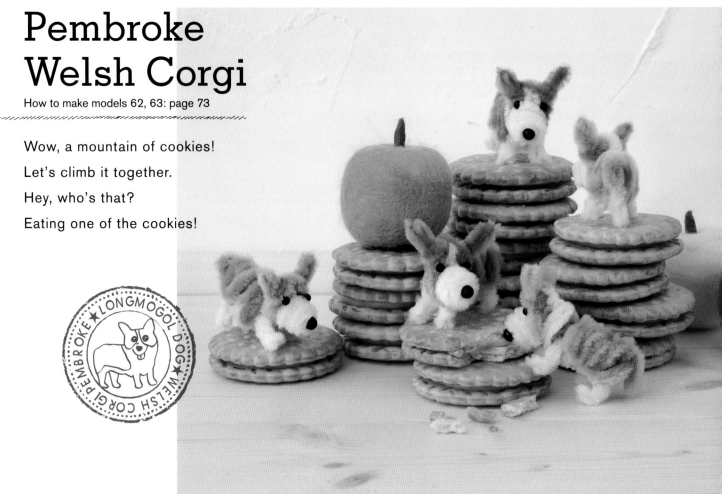

Making Pipe Cleaner Pets

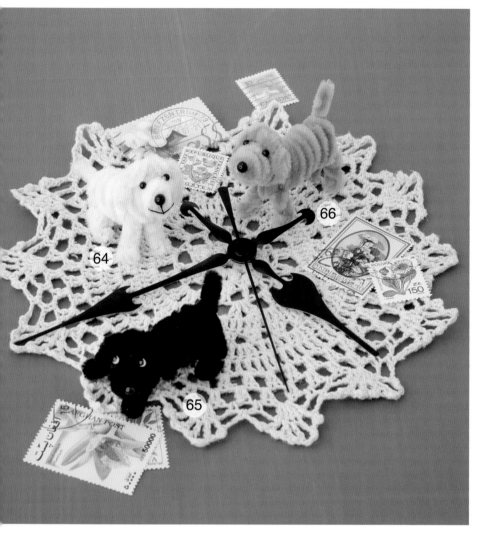

Labrador Retriever

How to make models 64–66: page 70

The usual time is so, so special
Right now is the most blessed
Right now is the most important

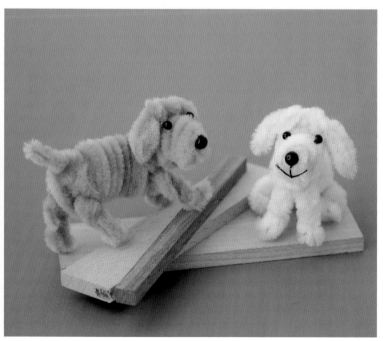

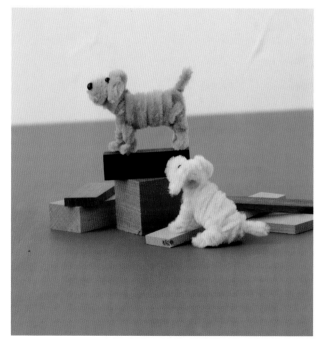

Hokkaido

How to make model 67: page 75
How to make model 68: page 74

Thank you for being born

Your birthday

Is the day I was reborn

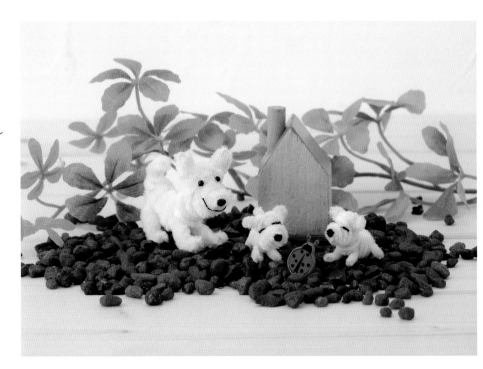

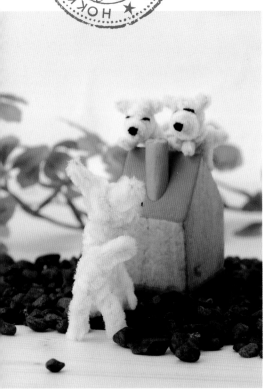

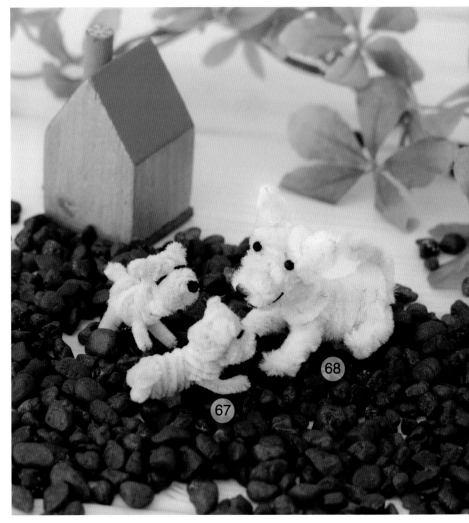

Making Pipe Cleaner Pets

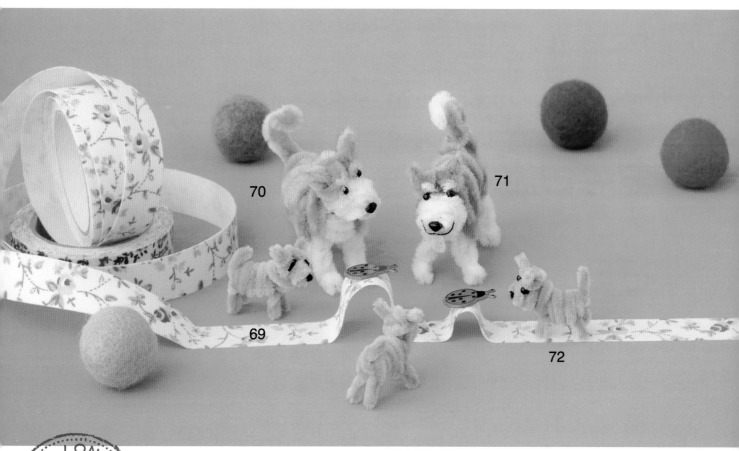

70

71

69

72

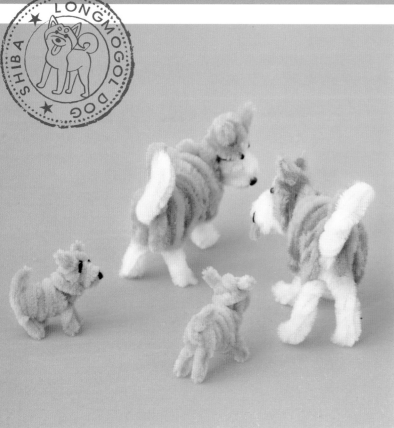

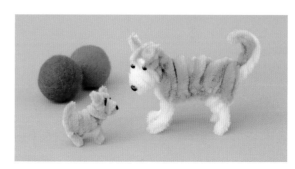

Shiba

How to make models 69, 72: page 77
How to make models 70, 71: page 76

Don't cry if you lose your way

Surely that path

Will take you somewhere

Miniature Pinscher

How to make model 73: page 85
How to make models 74, 75: page 86

The roads we gaze at

Are all different

After all, we're all heroes

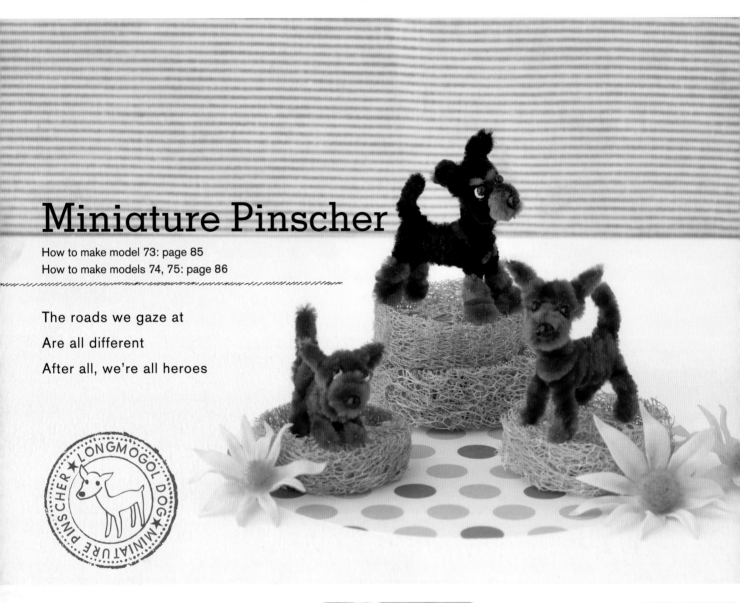

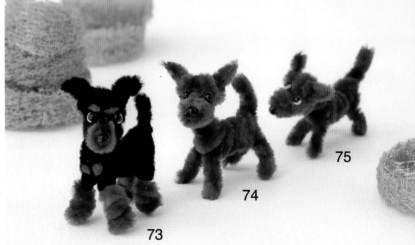

73

74

75

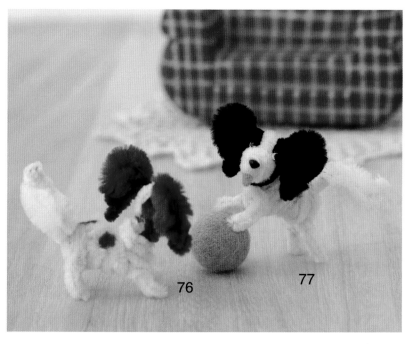

Papillon

How to make models 76, 77: page 78

Sometimes it's important

To spend time talking

With a special friend

76

77

Borzoi

How to make models 78, 79: page 80

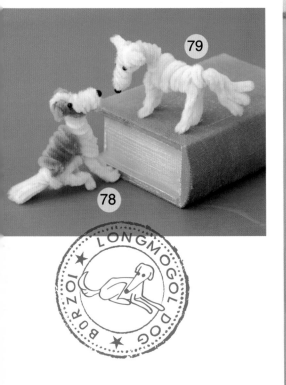

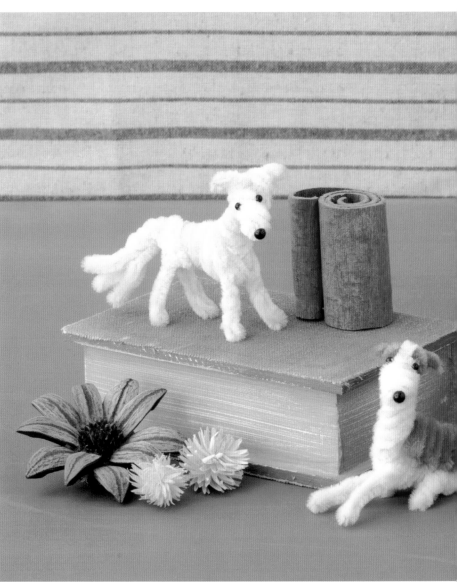

Dalmatian

How to make models 80, 81: page 82

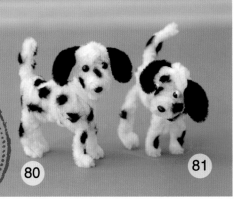

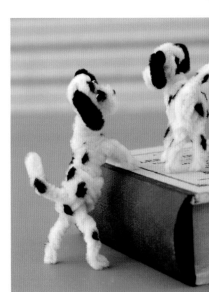

Making Pipe Cleaner Pets

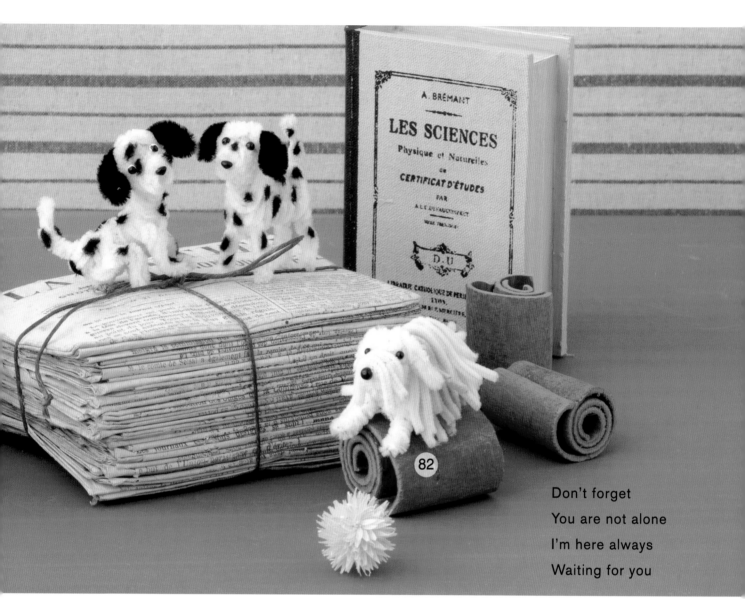

A. BRÉMANT

LES SCIENCES

Physique et Naturelles

ou

CERTIFICAT D'ÉTUDES

PAR

A. L. DEFAUCONPRET

D. U

LIBRAIRIE CATHOLIQUE DE PARIS

Don't forget

You are not alone

I'm here always

Waiting for you

Old English
Sheepdog

How to make model 82: page 72

How to Make the Toy Poodle

Model No. 1 (page 8)

This is the most basic model.
If you can learn this, it'll be easy to make the other dogs!

ACTUAL SIZE

MATERIALS

Model No. 1 (page 8)
- One 6mm beige pipe cleaner, approx. 40" (1m)
- Two 3mm toy eyes
- One 4.5mm bear nose

How to Make the Other Models (page 8)

• **Model No. 2**

Make the same way as No. 1, but use gray pipe cleaner.

• **Model No. 3**

Make the same way as No. 1, but use red brown pipe cleaner.

• **Model No. 4**

Make the same way as No. 1, but use medium brown pipe cleaner.

• **Model No. 5**

Make the same way as No. 1., but glue a ⅜" (1cm) length of copper pipe cleaner to the head to make a pointy hairstyle.

• **Model No. 6**

Make the same way as No. 1, using ivory pipe cleaner. Make the eyes using black pipe cleaner (see p. 75). Make the mouth with a piece of thick black thread (see p. 74).

• **Model No. 7**

Make the same way as No. 1., using black pipe cleaner, and paint on eye whites (see p. 79).

All pipe cleaners used should be 40" (1m) long unless otherwise noted.

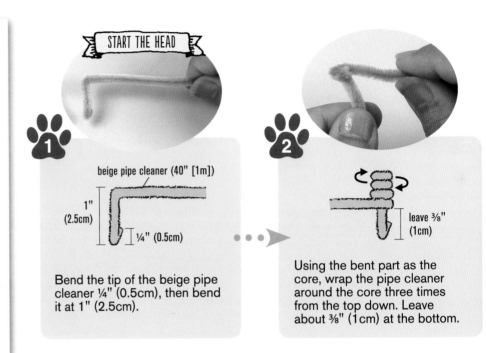

START THE HEAD

1

beige pipe cleaner (40" [1m])

1" (2.5cm)

¼" (0.5cm)

Bend the tip of the beige pipe cleaner ¼" (0.5cm), then bend it at 1" (2.5cm).

2

leave ⅜" (1cm)

Using the bent part as the core, wrap the pipe cleaner around the core three times from the top down. Leave about ⅜" (1cm) at the bottom.

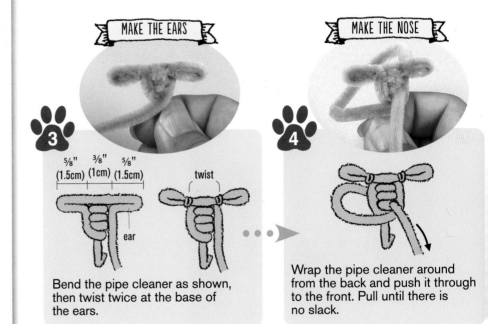

MAKE THE EARS

3

⅝" (1.5cm) ⅜" (1cm) ⅝" (1.5cm)

twist

ear

Bend the pipe cleaner as shown, then twist twice at the base of the ears.

MAKE THE NOSE

4

Wrap the pipe cleaner around from the back and push it through to the front. Pull until there is no slack.

Making Pipe Cleaner Pets

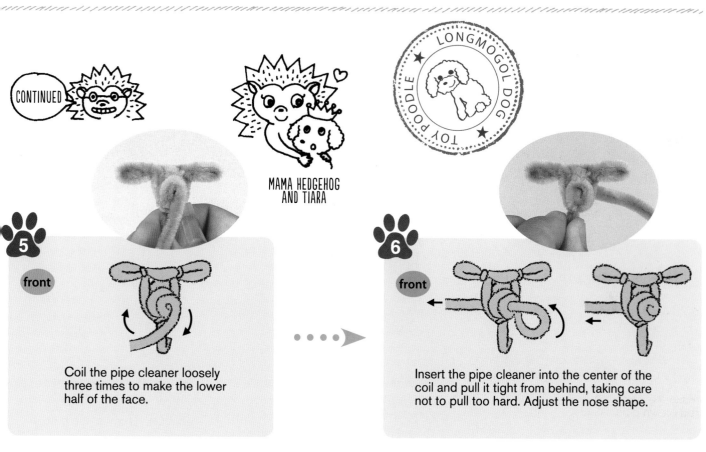

CONTINUED

MAMA HEDGEHOG
AND TIARA

LONGMOGOL DOG
TOY POODLE

5 front
Coil the pipe cleaner loosely three times to make the lower half of the face.

6 front
Insert the pipe cleaner into the center of the coil and pull it tight from behind, taking care not to pull too hard. Adjust the nose shape.

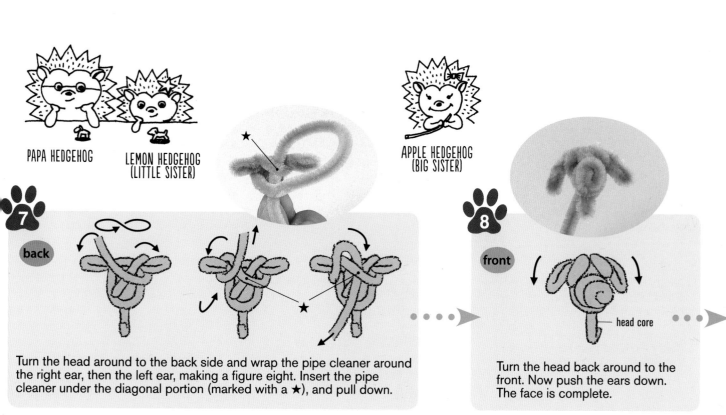

PAPA HEDGEHOG

LEMON HEDGEHOG
(LITTLE SISTER)

APPLE HEDGEHOG
(BIG SISTER)

7 back
Turn the head around to the back side and wrap the pipe cleaner around the right ear, then the left ear, making a figure eight. Insert the pipe cleaner under the diagonal portion (marked with a ★), and pull down.

8 front
head core

Turn the head back around to the front. Now push the ears down. The face is complete.

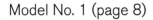

LONGMOGOL DOG ★ TOY POODLE ★

MAKE THE TAIL

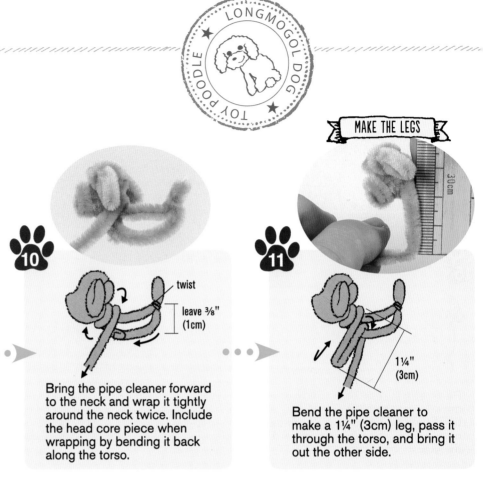

MAKE THE LEGS

9

⅝" (1.5cm)

¾" (2cm)

Bend the pipe cleaner coming out of the back of the head as shown. Twist the ⅝" (1.5cm) section to make the tail.

10

twist

leave ⅜" (1cm)

Bring the pipe cleaner forward to the neck and wrap it tightly around the neck twice. Include the head core piece when wrapping by bending it back along the torso.

11

1¼" (3cm)

Bend the pipe cleaner to make a 1¼" (3cm) leg, pass it through the torso, and bring it out the other side.

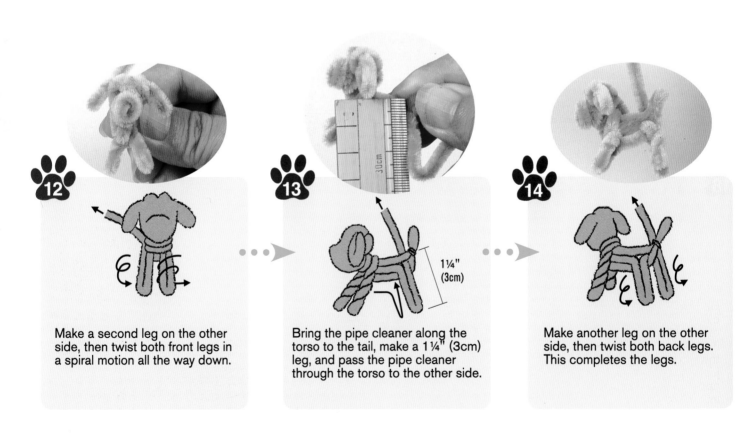

12

Make a second leg on the other side, then twist both front legs in a spiral motion all the way down.

13

1¼" (3cm)

Bring the pipe cleaner along the torso to the tail, make a 1¼" (3cm) leg, and pass the pipe cleaner through the torso to the other side.

14

Make another leg on the other side, then twist both back legs. This completes the legs.

Making Pipe Cleaner Pets

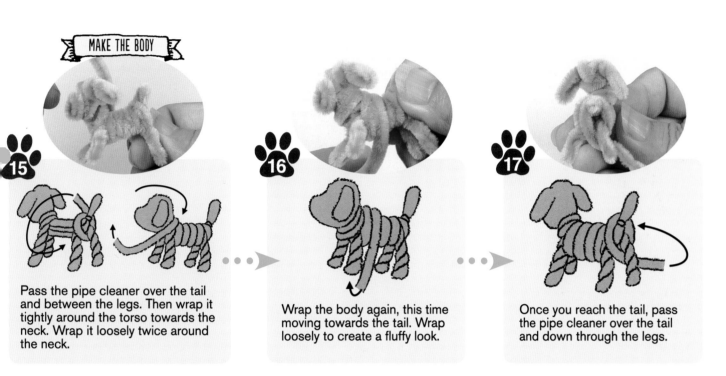

MAKE THE BODY

15 Pass the pipe cleaner over the tail and between the legs. Then wrap it tightly around the torso towards the neck. Wrap it loosely twice around the neck.

16 Wrap the body again, this time moving towards the tail. Wrap loosely to create a fluffy look.

17 Once you reach the tail, pass the pipe cleaner over the tail and down through the legs.

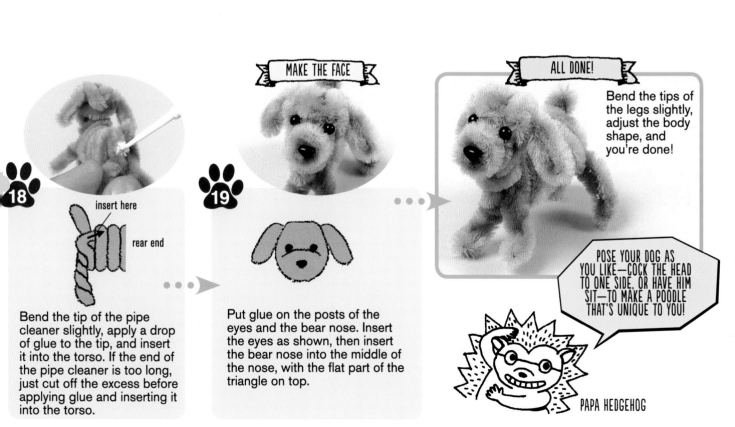

18 Bend the tip of the pipe cleaner slightly, apply a drop of glue to the tip, and insert it into the torso. If the end of the pipe cleaner is too long, just cut off the excess before applying glue and inserting it into the torso.

insert here

rear end

MAKE THE FACE

19 Put glue on the posts of the eyes and the bear nose. Insert the eyes as shown, then insert the bear nose into the middle of the nose, with the flat part of the triangle on top.

ALL DONE!

Bend the tips of the legs slightly, adjust the body shape, and you're done!

POSE YOUR DOG AS YOU LIKE—COCK THE HEAD TO ONE SIDE, OR HAVE HIM SIT—TO MAKE A POODLE THAT'S UNIQUE TO YOU!

PAPA HEDGEHOG

How to Make the Pug

Model No. 33 (page 20)

The key to this dog is the forehead wrinkles.

You can create an expressive face by making the base in 6mm pipe cleaner, then using 3mm pipe cleaner for the wrinkles.

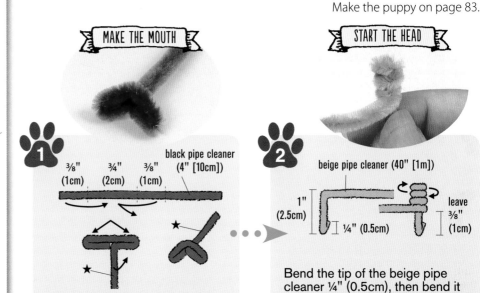

ACTUAL SIZE

Make the puppy on page 83.

MATERIALS

Model No. 33 (page 20)

- One 6mm beige pipe cleaner, approx. 40" (1m)
- One 6mm black pipe cleaner, approx. 12" (30cm)
- Two 3.5mm toy eyes
- One 4.5mm bear nose

How to Make the Other Models (page 20)

- Model No. 34

Make the same way as No. 33, using only black pipe cleaner.

- Model No. 37

Make the same way as No. 33, adding 3mm beige pipe cleaner wrinkles around the eyes and on the head. Use black toy eyes and paint on eye whites (see p. 79).

- Model No. 38

Make the same way as No. 34, adding 3mm black pipe cleaner wrinkles around the eyes and on the head. Use black toy eyes and paint on eye whites (see p. 79).

All pipe cleaners used should be 40" (1m) long unless otherwise noted.

MAKE THE MOUTH

1

⅜" (1cm) ¾" (2cm) ⅜" (1cm) black pipe cleaner (4" [10cm])

Cut a 4" (10cm) section of black pipe cleaner, bend the first third at a 90 degree angle, then arrange the short end (marked with a ★) to bend towards the corner. This will be the mouth.

*A brown pipe cleaner is used here instead of black to make it easier to see.

START THE HEAD

2

beige pipe cleaner (40" [1m])

1" (2.5cm) ¼" (0.5cm) leave ⅜" (1cm)

Bend the tip of the beige pipe cleaner ¼" (0.5cm), then bend it at 1" (2.5cm). Using the bent part as the core, wrap the pipe cleaner around the core three times from the top down. Leave about ⅜" (1cm) at the bottom.

MAKE THE EARS

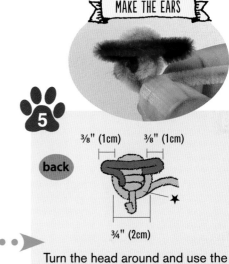

5

back ⅜" (1cm) ⅜" (1cm)

¾" (2cm)

Turn the head around and use the remaining black pipe cleaner to make the ears. Again, hold the ★ portion while adjusting the shape.

3

Bend the pipe cleaner as shown.

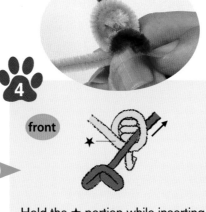

4

front

Hold the ★ portion while inserting the black mouth made in step 1.

Making Pipe Cleaner Pets

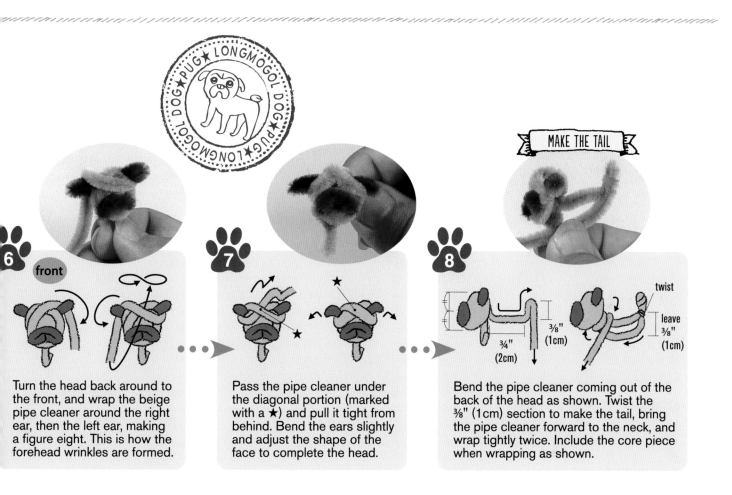

6

front

Turn the head back around to the front, and wrap the beige pipe cleaner around the right ear, then the left ear, making a figure eight. This is how the forehead wrinkles are formed.

7

Pass the pipe cleaner under the diagonal portion (marked with a ★) and pull it tight from behind. Bend the ears slightly and adjust the shape of the face to complete the head.

MAKE THE TAIL

8

¾" (2cm)

⅜" (1cm)

twist

leave ⅜" (1cm)

Bend the pipe cleaner coming out of the back of the head as shown. Twist the ⅜" (1cm) section to make the tail, bring the pipe cleaner forward to the neck, and wrap tightly twice. Include the core piece when wrapping as shown.

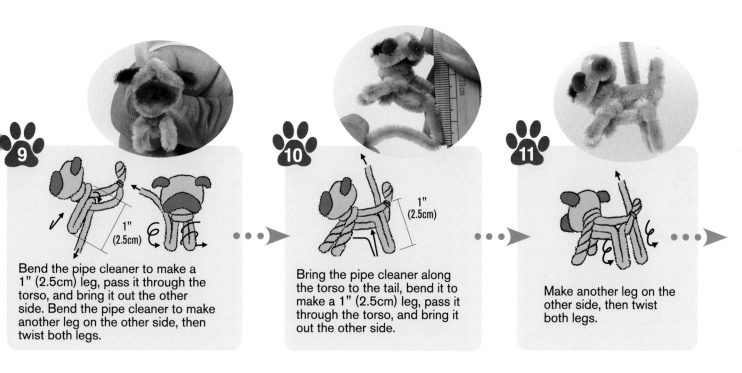

9

1" (2.5cm)

Bend the pipe cleaner to make a 1" (2.5cm) leg, pass it through the torso, and bring it out the other side. Bend the pipe cleaner to make another leg on the other side, then twist both legs.

10

1" (2.5cm)

Bring the pipe cleaner along the torso to the tail, bend it to make a 1" (2.5cm) leg, pass it through the torso, and bring it out the other side.

11

Make another leg on the other side, then twist both legs.

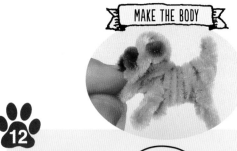

MAKE THE BODY

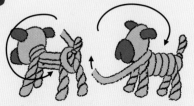

12

Pass the pipe cleaner over the tail and between the legs and wrap it tightly around the torso towards the neck. Once you reach the neck, wrap it more loosely once around the neck.

13

Next, wrap it loosely around the torso towards the tail, to create a fluffy look.

14

Once the pipe cleaner reaches the tail, pass it over the tail and down through the legs. If there is any pipe cleaner left over, leave a little extra for step 15 and cut off the rest.

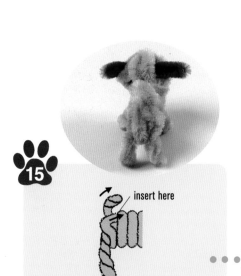

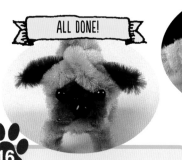

ALL DONE!

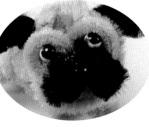

FOR AN EVEN MORE EXPRESSIVE DOG, USE 3MM PIPE CLEANER TO MAKE MORE FOREHEAD WRINKLES!

15

insert here

Bend the tip of the pipe cleaner slightly, apply a drop of glue to the tip, and insert it into the torso. Finally, bend the tail forward slightly.

16

Put some glue on the face where the eyes and nose will go. Insert the nose in the middle of the mouth made from black pipe cleaner, and insert the eyes as shown. Bend the legs slightly, adjust the body shape, and you're done!

Use a small brush and water-based enamel or acrylic paint to draw on eye whites (see p. 79).

• VARIATIONS •
Making the forehead wrinkles for 37/38

3mm pipe cleaner
1¼" (3cm)

3mm pipe cleaner
¾" (2cm) each

insert into the cheeks

Making Pipe Cleaner Pets

How to Make the Boston Terrier

Model No.19 (page 15)

The contrasting mouth, neck, and feet and the slightly droopy mouth make this dog design a true Boston Terrier.

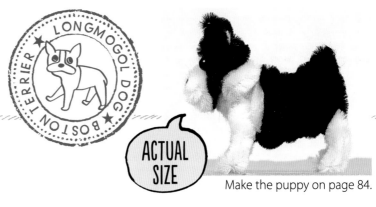

LONGMOGOL DOG BOSTON TERRIER

ACTUAL SIZE

Make the puppy on page 84.

MATERIALS
Model No. 19 (page 15)
- One 6mm white pipe cleaner, approx. 40" (1m)
- One 6mm black pipe cleaner, approx. 12" (30cm)
- Two 4mm toy eyes
- One 4.5mm bear nose

How to Make the Other Models (page 15)

• Model No. 18

Make the same way as No. 19, and draw eye whites around the outside of black toy eyes with water-based enamel (see p. 79).

• Model No. 20

Make the same way as No. 18, take some of the leftover pipe cleaner from step 13, and attach it to the belly.

All pipe cleaners used should be 40" (1m) long unless otherwise noted.

see p. 79

START THE HEAD

1

black pipe cleaner (12" [30cm])

1" (2.5cm) ¼" (0.5cm) leave ⅜" (1cm)

Bend the tip of the black pipe cleaner ¼" (0.5cm), then bend it at 1" (2.5cm). Using the bent part as the core, wrap the pipe cleaner around the core three and a half times from the top down. Leave about ⅜" (1cm) at the bottom.

*A gray-brown pipe cleaner is used here instead of black to make it easier to see.

MAKE THE EARS

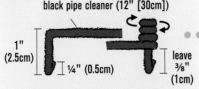

2

⅜" (1cm) ⅜" (1cm) ⅜" (1cm) twist

ear

Bend the pipe cleaner as shown, then twist twice at the base of the ears.

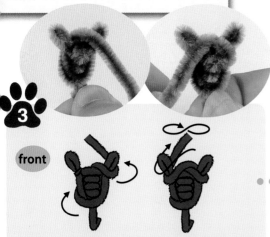

3

front

Bring the pipe cleaner around from the back to the front, and wrap it around the right ear, then the left ear, making a figure eight.

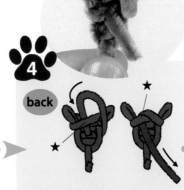

4

back

Turn the head around, pass the pipe cleaner under the diagonal portion (marked with a ★), and pull it down.

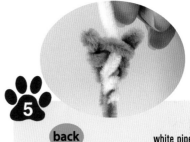
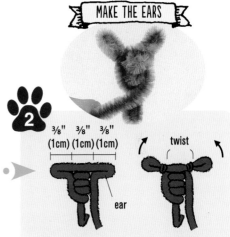

5

back

white pipe cleaner (40" [1m])

Insert the white pipe cleaner where the ★ is shown, and twist the black pipe cleaner around it to hold it in place. Cut them so they are the same length as the head core.

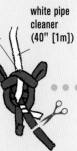

LONGMOGOL DOG ★ BOSTON TERRIER ★

MAKE THE MOUTH

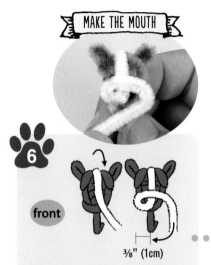

6

front

³⁄₈" (1cm)

Bring the white pipe cleaner around from the back to the front and down the center of the face. Bend it as shown to make the lower half of the face.

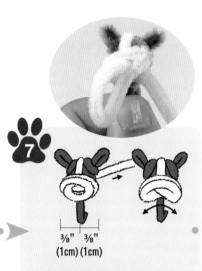

7

³⁄₈" ³⁄₈"
(1cm) (1cm)

Wrap it around twice, then insert it into the center and pull it out the back of the head. Bend down the corners and adjust the shape. This will be the mouth.

MAKE THE TAIL

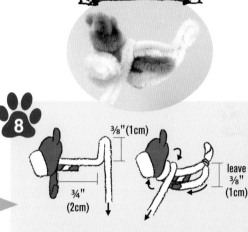

8

³⁄₈"(1cm)

leave ³⁄₈" (1cm)

³⁄₄" (2cm)

Bend the pipe cleaner coming out of the back of the head as shown. Fold back the the twisted piece from step 5. Twist the ³⁄₈" (1cm) section to make the tail, bring the pipe cleaner forward to the neck, and wrap tightly twice. Include the core piece when wrapping as shown.

MAKE THE LEGS

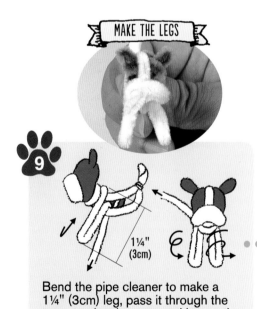

9

1¼" (3cm)

Bend the pipe cleaner to make a 1¼" (3cm) leg, pass it through the torso, and make a second leg on the other side. Twist both front legs.

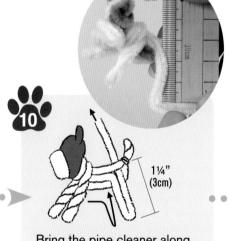

10

1¼" (3cm)

Bring the pipe cleaner along the torso to the tail, make a 1¼" (3cm) back leg, and pass the pipe cleaner through the torso to the other side.

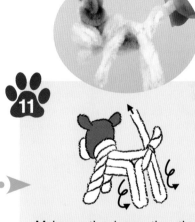

11

Make another leg on the other side, then twist both legs. The legs are complete.

Making Pipe Cleaner Pets

MAKE THE BODY

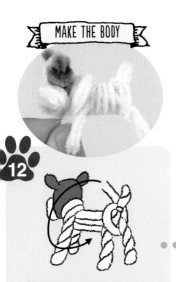

12

Pass the pipe cleaner over the tail and between the legs and wrap it tightly around the torso towards the neck.

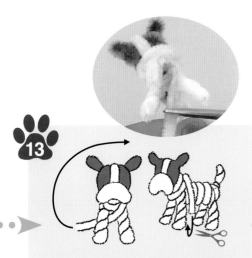

13

Once you reach the neck, bring it through the front legs and wrap it around the neck, then bring it back down to the belly. Trim the tip, put on a dab of glue, and insert it into the belly.

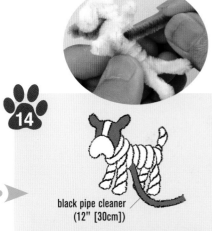

14

black pipe cleaner (12" [30cm])

Insert a black pipe cleaner with glue on the tip into the bottom of the belly and wind it around the entire body towards the tail, hiding the white. Wrap loosely to create a fluffy look.

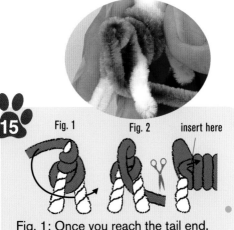

15

Fig. 1 Fig. 2 insert here

Fig. 1: Once you reach the tail end, pass the pipe cleaner between the legs and wind it up around the tail, covering the entire tail. Fig. 2: Bring it down through the back legs again and cut it with a little room to spare at the end. Bend the tip, add a dab of glue, and insert it into the torso.

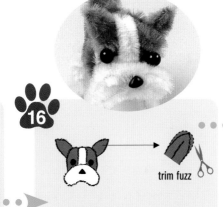

16

trim fuzz

Put glue on the posts of the eyes and nose. Insert the nose into the center of the mouth that was made at steps 6–7, and insert the eyes above the mouth.

ALL DONE!

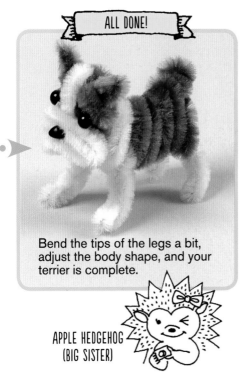

Bend the tips of the legs a bit, adjust the body shape, and your terrier is complete.

APPLE HEDGEHOG (BIG SISTER)

Ideas for Accessories

By attaching accessory findings, you can bring your dogs with you wherever you go.

You can also pose the dogs however you like.

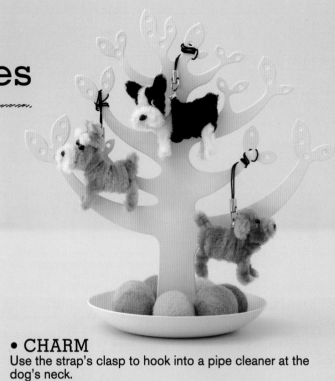

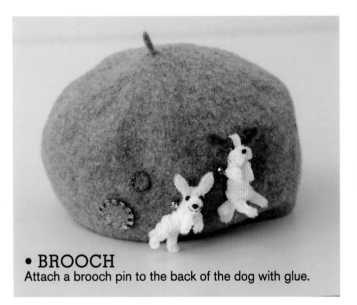

• BROOCH
Attach a brooch pin to the back of the dog with glue.

• CHARM
Use the strap's clasp to hook into a pipe cleaner at the dog's neck.

• HAIR PIN
Stick a puppy to a hair pin that has a glue pad.

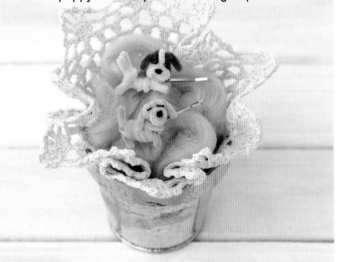

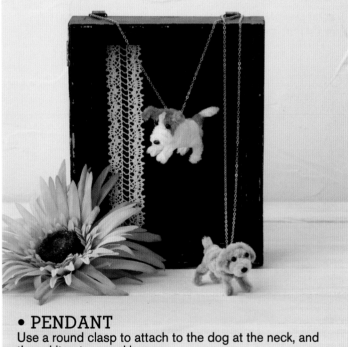

• PENDANT
Use a round clasp to attach to the dog at the neck, and thread it onto a necklace.

Making Pipe Cleaner Pets

Materials and Tools

If you can't find long pipe cleaners, use four or five shorter pipe cleaners twisted together.
When twisting together several pipe cleaners, be careful not to hurt yourself on the ends of the wires.

MATERIALS

• Long pipe cleaners
40" (1m) 6mm pipe cleaners come in many colors.

• Small pipe cleaners
Some pipe cleaners are available in 3mm, which is thinner and useful for dog features and details.

• Thread (cotton)
Use thread for mouth lines. Thick thread is best.

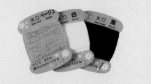

• Craft glue
Use glue to fix pipe cleaner ends in place, attach eyes, noses, and mouths, and attach fur spots on the body.

• Wavy pipe cleaners
This special pipe cleaner is used to make the Papillon.

• Water-based paint
Toy eyes are generally black, so you can use paint to add eye whites. Acrylic paint works too.

• Brooch pins & hair pins
Glue your dog to any type of pin to make a brooch or hair pin.

• Bear noses
Put some craft glue on the base and insert at the proper place.

• Felt
Cut small pieces of felt for noses and eyes. This book uses felt for tongues and puppy noses, too.

• Straps (with clasps)
A strap with a clasp is recommended. Attach it to your dog by affixing the clasp onto a pipe cleaner at the neck.

• Toy eyes
Put some craft glue on the base and insert at the proper place. Toy eyes can also be used as noses.

TOOLS

• Awl
Make holes with an awl before inserting the eyes and nose for easier placement.

• Ruler
Be sure to measure carefully as you make the dogs, because proportions are important.

• Needle-nose pliers
Use needle-nose pliers to bend pointy wire ends inward.

• Saucer (can lid or little tray)
Use a saucer (or a can lid) to hold hair trimmed from a pipe cleaner.

• Fine-tipped brush
Use a very fine-tipped brush to draw on eye whites.

• Scissors
Use sharp scissors to trim the hair off pipe cleaners. An ordinary pair of scissors can be used to cut the pipe cleaners themselves.

• ADVICE FROM PAPA HEDGEHOG

Dogs made of pipe cleaners can be posed easily by bending their legs and neck. By changing the way you wrap the pipe cleaner, you can change the result. The dog you've made is unique in the world: it's yours alone!

COME MAKE ONE TOGETHER WITH ME!

PAPA HEDGEHOG

Finished pose

By painting a little white onto the eyes, your dog's facial expression will become more animated. Use water-based enamel on its own or dilute some acrylic paint. Apply the paint with a fine-tipped brush, and affix the eyes to the face after they dry.

Making Pipe Cleaner Pets

How to Make the Chihuahua

Model No. 11 (page 10)

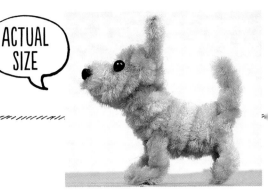

ACTUAL SIZE

The chihuahua's distinctive feature is its "apple head". Keep a round form in mind when shaping the head. Trim the hair a little on the tips of the ears to make them pointy and more chihuahua-like.

MATERIALS

Model No. 11 (page 10)
- One 6mm beige pipe cleaner, approx. 40" (1m)
- Two 4mm toy eyes
- One 4.5mm bear nose

How to Make the Other Models (pages 10–11)

• Model No. 9

Make the same way as No. 11, using white pipe cleaner, and cut the hair from a light pink pipe cleaner to glue to the inside of the ears and the belly. Make a mouth with thick thread (see p. 74).

• Model No. 12

Make the same way as No. 11, using ivory pipe cleaner.

All pipe cleaners used should be 40" (1m) long unless otherwise noted.

1 START THE HEAD

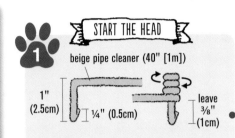

beige pipe cleaner (40" [1m])

1" (2.5cm) ¼" (0.5cm) leave ⅜" (1cm)

Bend the tip of the beige pipe cleaner ¼" (0.5cm), then bend it at 1" (2.5cm). Using the bent part as the core, wrap the pipe cleaner around the core three and a half times from the top down. Leave about ⅜" (1cm) at the bottom.

2 MAKE THE EARS

⅜" (1cm) ear twist

¾" (2cm) ¾" (2cm)

Bend as shown, then twist twice at the base of the ears.

3 MAKE THE NOSE

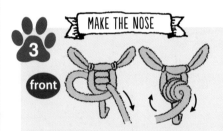

front

Wrap the pipe cleaner around to the back and push it through to the front. Pull until there is no slack. Coil the pipe cleaner loosely four times to make the lower half of the face.

4

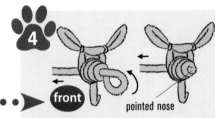

front pointed nose

Insert the pipe cleaner into the center of the coil and pull it tight from behind, taking care not to pull too hard. Shape the nose to make it slightly pointed.

5

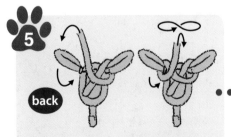

back

Turn the head around and wrap the pipe cleaner around the right ear, then the left ear, making a figure eight.

6

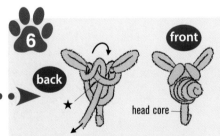

front back head core

Pass the pipe cleaner under the diagonal portion (★) and pull it down. Shape the head to make it rounded.

7 MAKE THE TAIL

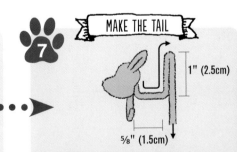

1" (2.5cm) ⅝" (1.5cm)

Bend the pipe cleaner coming out of the back of the head as shown. Twist the 1" (2.5cm) section to make the tail.

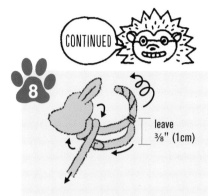

8

Bring the pipe cleaner forward to the neck and wrap tightly twice. Include the core piece when wrapping.

leave ⅜" (1cm)

9
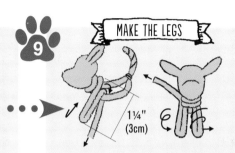

MAKE THE LEGS

Bend the pipe cleaner to make a 1¼" (3cm) leg, pass it through the torso, and make a second leg on the other side. Twist both legs.

1¼" (3cm)

10
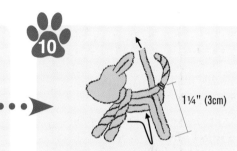

Bring the pipe cleaner along the torso to the tail, make a 1¼" (3cm) back leg, and pass the pipe cleaner through the torso to the other side.

1¼" (3cm)

11
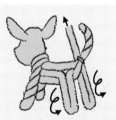

Make another leg on the other side, then twist both legs.

12
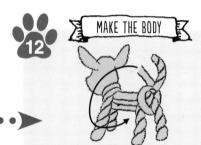

MAKE THE BODY

Pass the pipe cleaner over the tail and between the legs and wrap it tightly around the torso towards the neck. Then wrap it loosely twice around the neck.

13
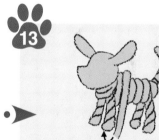

Wrap the body again, moving towards the tail. Wrap loosely to create a fluffy look.

14
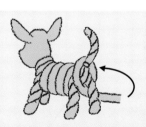

Once you reach the tail, pass the pipe cleaner over the tail and down through the legs.

15

insert here

Bend the tip of the pipe cleaner slightly, apply a drop of glue to the tip, and insert it into the torso.

16
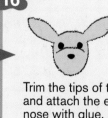

ALL DONE!

trim fuzz

Trim the tips of the ears and attach the eyes and nose with glue. Bend the front and back legs slightly, adjust the body shape, and you're done!

How to Make the Chihuahua

Model No.10 (page 10)

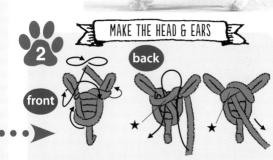

ACTUAL SIZE

This chihuahua features a different color nose and legs.

MATERIALS
Model No. 10 (page 10)
- One 6mm black pipe cleaner, approx. 40" (1m)
- Two 6mm beige pipe cleaners, approx. 12" (30cm)
- Two 4mm toy eyes
- One 4.5mm bear nose

How to Make the Other Model (page 10)

- Model No. 8
 - One 6mm ivory pipe cleaner, approx. 40" (1m)
 - One 6mm copper pipe cleaner, approx. 40" (1m)
 - One 6mm light pink pipe cleaner, approx. 12" (30cm)

Cut the copper pipe cleaner to 12" (30cm), and follow step 2 to make the head and ears. Make the nose from the ivory pipe cleaner, following steps 4–6 p. 66 (coil four times). Make the body from the ivory pipe cleaner that comes out the back of the head, following step 7 p. 48. Cut some copper pipe cleaner fuzz to attach around the tail for spots. Cut some light pink pipe cleaner fuzz for the insides of the ears. Don't paint whites on the eyes.

All pipe cleaners used should be 40" (1m) long unless otherwise noted.

1 · MAKE THE LEGS

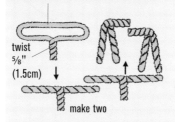

beige pipe cleaner (6" [15cm])

twist
⅝"
(1.5cm)

make two

Cut one beige pipe cleaner in half and bend it as shown to make two legs.

2 · MAKE THE HEAD & EARS

front · back

Using the black pipe cleaner, follow steps 1–2 p. 48. Then bring the pipe cleaner around from the back to the front, making a figure eight around the ears. Bring it back around to the back, pass it under the diagonal portion (★), and pull it down.

3 · MAKE THE NOSE

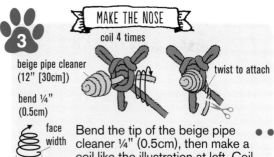

coil 4 times

beige pipe cleaner (12" [30cm])

bend ¼" (0.5cm)

twist to attach

face width

Bend the tip of the beige pipe cleaner ¼" (0.5cm), then make a coil like the illustration at left. Coil four times, then insert the pipe cleaner into the center of the coil, taking care not to pull too hard. Insert the nose into the front of the face and twist it with the black pipe cleaner coming out of the head to hold it in place. Cut off the excess, and trim some fuzz to glue on later as ears and eyebrows.

4 · MAKE THE BODY

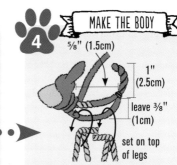

⅝" (1.5cm)

1" (2.5cm)

leave ⅜" (1cm)

set on top of legs

Using the black pipe cleaner coming out the back of the head, make the torso as shown (see step 7 p. 48 and step 8 p. 49). Next, set the body on top of the legs made in step 1.

5

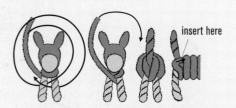

insert here

Attach the front legs by wrapping in a V shape as shown. Then wrap the pipe cleaner loosely around the torso from neck to tail. Attach the back legs and wrap around the tail to keep them in place. Cut off any excess pipe cleaner, bend the tip slightly, apply a drop of glue, and insert it into the torso.

6 · ALL DONE!

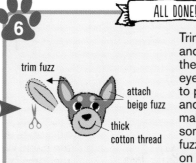

trim fuzz

attach beige fuzz

thick cotton thread

Trim the tips of the ears and use glue to attach the mouth, nose, and eyes (see p. 79 for how to paint on eye whites, and p. 74 for how to make the mouth). Glue some beige pipe cleaner fuzz above the eyes and on the inside of the ears. Bend the legs slightly, adjust the body shape, and you're done!

How to Make the Miniature Bull Terrier

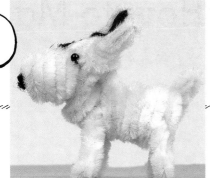

ACTUAL SIZE

Model No. 60 (page 27)

This terrier has a black eyepatch on an elongated face.

MATERIALS
Model No. 60 (page 27)
- One 6mm ivory pipe cleaner, approx. 40" (1m)
- One 6mm light pink pipe cleaner, approx. 12" (30cm)
- Two 3.5mm toy eyes
- Black felt for nose

How to Make the Other Model (page 27)

- Model No. 61
Make the same way as No. 60, but without spots, and use 2.5mm toy eyes.

All pipe cleaners used should be 40" (1m) long unless otherwise noted.

LONGMOGOL DOG ★ MINIATURE BULL TERRIER

1 START THE HEAD
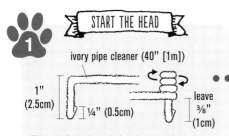
ivory pipe cleaner (40" [1m])
1" (2.5cm) ¼" (0.5cm) leave ⅜" (1cm)

Bend the tip of the ivory pipe cleaner ¼" (0.5cm), then bend it at 1" (2.5cm). Using the bent part as the core, wrap the pipe cleaner around the core three and a half times from the top down. Leave about ⅜" (1cm) at the bottom.

2 MAKE THE EARS
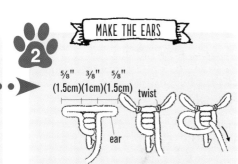
⅝" (1.5cm) ⅜" (1cm) ⅝" (1.5cm) twist ear

Bend as shown, then twist twice at the base of the ears. Wrap the pipe cleaner around to the back and push it through to the front. Pull until there is no slack.

3
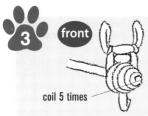
front
coil 5 times

Coil the pipe cleaner loosely five times for the nose, then insert it into the center of the coil. Pull it tight from behind, taking care not to pull too hard. Press the nose gently into a slightly squished shape.

4
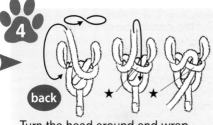
back

Turn the head around and wrap the pipe cleaner around the ears in a figure eight. Pass it under the diagonal portion (marked with a ★), pull it down tightly, and adjust the face shape.

5 MAKE THE TAIL & LEGS
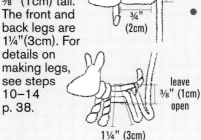
⅜" (1cm) ¾" (2cm) leave ⅜" (1cm) open 1¼" (3cm)

Bend the pipe cleaner coming out of the back of the head as shown, making a ⅜" (1cm) tail. The front and back legs are 1¼" (3cm). For details on making legs, see steps 10–14 p. 38.

6 MAKE THE BODY

Pass the pipe cleaner over the tail and between the legs, then wrap it tightly around the torso towards the neck. Wrap it loosely around the torso back towards the tail, then insert the tip with a little glue into the torso. For details on wrapping the body, see steps 15–18 p. 39.

7 ALL DONE!
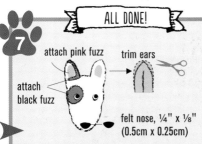
attach pink fuzz trim ears attach black fuzz felt nose, ¼" x ⅛" (0.5cm x 0.25cm)

Use glue to attach a felt nose and eyes with eye whites painted on (see p. 79 for how to paint the eyes). Make the eyepatch and ear spot with black pipe cleaner fuzz. Glue pink pipe cleaner fuzz on the inside of the ears. Bend the legs slightly, adjust the body shape, and you're done!

Making Pipe Cleaner Pets

How to Make the Miniature Schnauzer

Model No. 16 (page 12)

ACTUAL SIZE

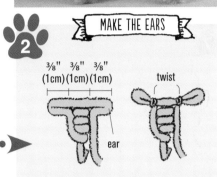

Make the beard and eyebrows with a different color, give him a pair of glasses, and you have a scholarly schnauzer!

MATERIALS
Model No. 16 (page 12)
- One 6mm gray pipe cleaner, approx. 40" (1m)
- One 6mm white pipe cleaner, approx. 12" (30cm)
- Two 3.5mm toy eyes
- One 4.5mm bear nose
- 4" (10cm) of 1mm gold craft wire for glasses

How to Make the Other Models (page 12)

- **Model No. 13**
 - One 6mm gray pipe cleaner, approx. 40" (1m)
 - One 6mm white pipe cleaner, approx. 12" (30cm)
 - One 6mm black pipe cleaner, approx. 12" (30cm) for the eyes

 Using the two-colored chihuahua (p. 50) for reference, make white legs. The size of the body and the method is the same as No. 16. Use black pipe cleaner for the eyes (see p. 75). Do not make glasses.

- **Model No. 14**
 - One 6mm white pipe cleaner, approx. 40" (1m)
 - One 6mm gray pipe cleaner, approx. 12" (30cm)

 Make the same way as No. 16, but with colors reversed and no glasses.

- **Model No. 15**
 - One 6mm white pipe cleaner, approx. 40" (1m)

 Make the same way as No. 16, but using only one color and no glasses. Cut a 2" (5cm) length for the mouth and two ⅜" (1cm) lengths for the eyebrows before you begin.

All pipe cleaners used should be 40" (1m) long unless otherwise noted.

1 START THE HEAD

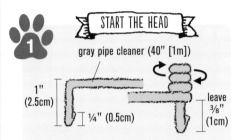

gray pipe cleaner (40" [1m])

1" (2.5cm) ¼" (0.5cm) leave ⅜" (1cm)

Bend the tip of the gray pipe cleaner at ¼" (0.5cm), then bend it at 1" (2.5cm). Using the bent part as the core, wrap the pipe cleaner around the core three and a half times from the top down. Leave about ⅜" (1cm) at the bottom.

2 MAKE THE EARS

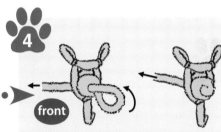

⅜" (1cm) ⅜" (1cm) ⅜" (1cm) twist

ear

Bend as shown, then twist twice at the base of the ears.

3 MAKE THE NOSE

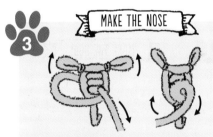

Wrap the pipe cleaner around to the back and push it through to the front. Pull until there is no slack. Coil the pipe cleaner loosely once to make the lower half of the face. Raise the ears.

4

front

Insert the pipe cleaner into the center of the coil and pull it tight from behind, taking care not to pull too hard.

5

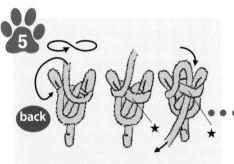

back

Turn the head around and wrap the pipe cleaner around the ears in a figure eight. Pass it under the diagonal portion (marked with a ★) and pull it down.

6 MAKE THE TAIL

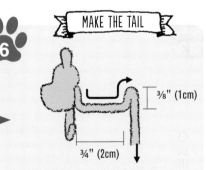

⅜" (1cm) ¾" (2cm)

Bend the pipe cleaner coming out of the back of the head as shown. Twist the ⅜" (1cm) section twice at the base to make the tail.

ATSUSHI
HEDGEHOG

CONTINUED

MAKE THE LEGS

7 twist

leave
⅜"
(1cm)
open

1¼"
(3cm)

Bring the pipe cleaner forward to the neck and wrap tightly twice. Include the core piece when wrapping. Bend the pipe cleaner to make a 1¼" (3cm) leg and pass it through the torso to the other side.

8

Make another leg on the other side, then twist both legs.

9

1¼" (3cm)

Bring the pipe cleaner along the torso to the tail, make a 1¼" (3cm) back leg, and pass it through the torso to the other side.

10

Make another leg on the other side, then twist both back legs.

MAKE THE BODY

11

Pass the pipe cleaner over the tail and between the legs and wrap it tightly around the torso towards the neck.

12

Once you reach the neck, wrap it loosely twice around the neck. Wrap the body again, moving towards the tail. Wrap loosely to create a fluffy look.

13 insert here

Once you reach the tail, pass the pipe cleaner over the tail and down through the legs. Trim any excess pipe cleaner. Bend the tip slightly, apply a drop of glue, and insert it into the torso.

14

eyebrows

mouth
2" (5cm) of white pipe cleaner

actual size

glasses

4" (10cm)
of 1mm wire

Cut the white pipe cleaner into one 2" (5cm) and two ⅜" (1cm) lengths. To make the mouth, fold the tips of the longer piece into the center, then bend the ends downward. To make the eyebrows, bend the smaller pieces, watching out for the wires. Glue all three pieces to the face. Make the gold wire into a pair of glasses.

ALL DONE!

15

white pipe cleaner glasses

Glue on the eyes and nose. Put on the glasses and bring the arms of the glasses around to the back of the head. Bend the tips of the ears and feet slightly, adjust the body shape, and you're done!

How to Make the Cavalier King Charles Spaniel

Model No. 21 (page 16)

"Cavalier" is another word for "knight." Apply a unique fur pattern and make your very own furry knight in shining armor!

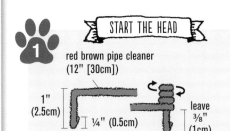

ACTUAL SIZE

MATERIALS
Model No. 21 (page 16)
- One 6mm ivory pipe cleaner, approx. 40" (1m)
- One 6mm red brown pipe cleaner, approx. 12" (30cm)
- Two 3.5mm toy eyes
- One 4.5mm bear nose

How to Make the Other Models (page 16)

• Model No. 23

Make the same way as 21, but paint on eye whites (see p. 79).

• Model No. 24

Make the same way as No. 21 but change the color of the ears and spots by using copper pipe cleaner. Paint on eye whites (see p. 79) and make the mouth with a piece of thick black thread (see p. 74).

• Model No. 25

Make the same way as No. 21 but changes the color of the ears and spots by using black pipe cleaner. Paint on eye whites (see p. 79).

All pipe cleaners used should be 40" (1m) long unless otherwise noted.

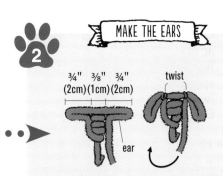

START THE HEAD (1)

red brown pipe cleaner (12" [30cm])

1" (2.5cm) — ¼" (0.5cm) — leave ⅜" (1cm)

Bend the tip of the red brown pipe cleaner ¼" (0.5cm), then bend it at 1" (2.5cm). Using the bent part as the core, wrap the pipe cleaner around the core three and a half times from the top down. Leave about ⅜" (1cm) at the bottom.

MAKE THE EARS (2)

¾" (2cm) ⅜" (1cm) ¾" (2cm) — twist — ear

Bend as shown, then twist twice at the base of the ears. Bring the pipe cleaner around to the back.

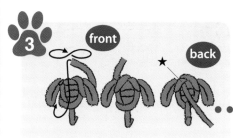

(3) front / back / ★

Wrap the pipe cleaner around the right ear, then the left ear, making a figure eight. Turn the head around, pass the pipe cleaner under the diagonal portion (marked with a ★), and pull it down.

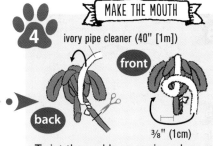

MAKE THE MOUTH (4)

ivory pipe cleaner (40" [1m]) / front / back / ⅜" (1cm)

Twist the red brown pipe cleaner and the ivory pipe cleaner together, and cut the ends so they are the same length as the head core. Bring the ivory pipe cleaner around from the back to the front and down the center of the face. Bend it as shown to make the lower half of the face.

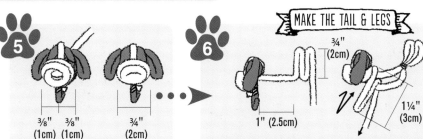

(5)

⅜" (1cm) ⅜" (1cm) ¾" (2cm)

Wrap it around twice, then insert it into the center and pull it out the back of the head. This will become the nose.

MAKE THE TAIL & LEGS (6)

¾" (2cm) / 1" (2.5cm) / 1¼" (3cm)

Bend the pipe cleaner coming out of the back of the head as shown, twisting the tail at the base. Bring the pipe cleaner forward to the neck and wrap tightly twice. Include the core piece when wrapping. Bend the pipe cleaner to make a 1¼" (3cm) leg and pass it through the torso to the other side.

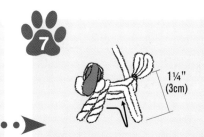

(7) 1¼" (3cm)

Make a second leg on the other side, then twist both front legs. Bring the pipe cleaner along the torso to the tail, make a 1¼" (3cm) back leg, and pass the pipe cleaner through the torso to the other side.

How to Make the Cavalier King Charles Spaniel Puppy

Model No. 22 (page 16)

Use 3mm pipe cleaners to make a cute puppy.

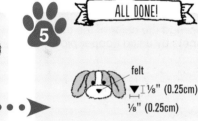

ACTUAL SIZE

MATERIALS
Model No. 22 (page 16)
- One 3mm red brown pipe cleaner, approx. 12" (30cm)
- Two 3mm ivory pipe cleaners, approx. 12" (30cm)
- Two 3mm toy eyes
- Black felt for nose

Use 12" (30cm) 3mm pipe cleaners for the puppies. Be careful not to hurt yourself on the ends of the wires.

1 START THE HEAD

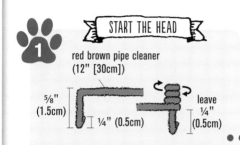

red brown pipe cleaner (12" [30cm])

5/8" (1.5cm) · 1/4" (0.5cm) · leave 1/4" (0.5cm)

Bend the tip of the red brown pipe cleaner 1/4" (0.5cm), then bend it at 5/8" (1.5cm). Using the bent part as the core, wrap the pipe cleaner around the core two and a half times from the top down. Leave about 1/4" (0.5cm) at the bottom.

2 MAKE THE EARS

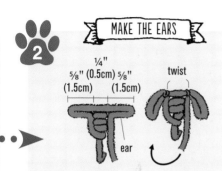

1/4" · 5/8" (0.5cm) 5/8" · twist
(1.5cm) (1.5cm)
ear

Bend as shown, then twist twice at the base of the ears. Bring the pipe cleaner around to the back.

3 MAKE THE NOSE

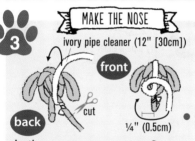

ivory pipe cleaner (12" [30cm])

front · back · cut · 1/4" (0.5cm)

In the same way as step 3 on the opposite page, wrap the pipe cleaner around the ears in a figure eight and wrap the ivory pipe cleaner around the red brown one. Make the mouth as shown on the opposite page in steps 4 and 5.

4 MAKE THE TAIL

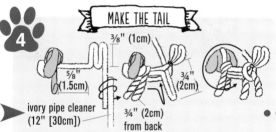

3/8" (1cm) · 5/8" (1.5cm) · 3/4" (2cm)
ivory pipe cleaner (12" [30cm]) · 3/4" (2cm) from back

Follow steps 6–9 to make the legs and body. At one point you will have to add another pipe cleaner: overlap them by 5/8" (1.5cm) and twist together. Cut off any excess pipe cleaner after wrapping the body, and insert the end into the torso with a drop of glue.

5 ALL DONE!

felt · 1/8" (0.25cm) · 1/8" (0.25cm)

Trim the fuzz from the extra pipe cleaner cut off in step 3 and glue it to the body to make patches. Attach the eyes and nose with glue. Bend the legs slightly, adjust the body shape, and you're done!

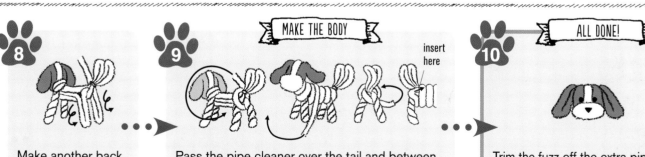

8
Make another back leg, then twist both back legs.

9 MAKE THE BODY
insert here

Pass the pipe cleaner over the tail and between the legs and wrap it tightly around the torso towards the neck. Wrap loosely twice around the neck, then wrap the body again, more loosely, towards the tail. Pass the pipe cleaner over the tail and down through the legs. Trim the end, bend the tip slightly, apply a drop of glue, and insert it into the torso.

10 ALL DONE!
Trim the fuzz off the extra pipe cleaner cut off in step 4 and glue it to the body to make patches of color. Attach the eyes and nose with glue. Bend the legs slightly, adjust the body shape, and you're done!

Making Pipe Cleaner Pets

How to Make the Miniature Dachshund

Model No. 27 (page 18)

This guy has a distinctive long body and short legs. Make a mischievous friend with a single red brown pipe cleaner.

ACTUAL SIZE

★ LONGMOGOL DOG ★ MINIATURE DACHSHUND

MATERIALS

Model No. 27 (page 18)

- One 6mm red brown pipe cleaner, approx. 40" (1m)
- One 6mm black pipe cleaner, approx. 12" (30cm), for ears
- Two 3.5mm toy eyes
- One 4mm bear nose

How to Make the Other Models (page 18)

- **Model No. 28**

Make the same way as No. 27, using beige pipe cleaner. Don't put fuzz from a black pipe cleaner in the ears. Don't paint eye whites or make a string mouth.

- **Model No. 30**

Make the same way as No. 27, using medium brown pipe cleaner. Don't put fuzz from a black pipe cleaner in the ears. Don't paint eye whites or make a string mouth.

All pipe cleaners used should be 40" (1m) long unless otherwise noted.

1 MAKE THE HEAD & EARS

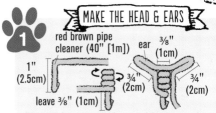

red brown pipe cleaner (40" [1m]) ear 3/8" (1cm)
1" (2.5cm) 3/4" (2cm) 3/4" (2cm)
leave 3/8" (1cm)

Bend the tip of the red brown pipe cleaner ¼" (0.5cm), then bend it at 1" (2.5cm). Using the bent part as the core, wrap the pipe cleaner around the core three and a half times from the top down. Leave about ⅜" (1cm) at the bottom. Bend as shown, then twist twice at the base of the ears.

2 MAKE THE NOSE

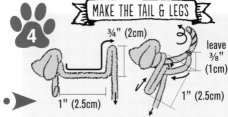

twist front coil 4 times

Wrap the pipe cleaner around to the back and push it through to the front. Pull until there is no slack. Coil the pipe cleaner loosely four times, insert the pipe cleaner into the center of the coil, and pull it tight from behind, taking care not to pull too hard. Shape the nose.

3

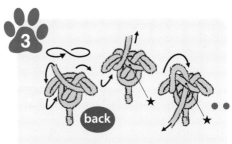

back

Turn the head around and wrap the pipe cleaner around the ears in a figure eight. Pass it under the diagonal portion (★) and pull it down.

4 MAKE THE TAIL & LEGS

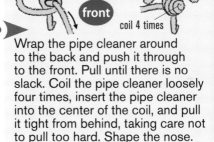

¾" (2cm) leave 3/8" (1cm)
1" (2.5cm) 1" (2.5cm)

Bend the pipe cleaner coming out of the back of the head as shown, twisting a ¾" (2cm) section for the tail. Bring the pipe cleaner forward to the neck and wrap tightly twice. Include the core piece when wrapping. Make two 1" (2.5cm) front legs as shown.

5 MAKE THE BODY

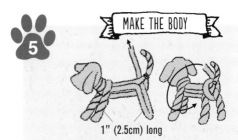

1" (2.5cm) long

Twist the front legs. Bring the pipe cleaner along the torso to the tail and make two 1" (2.5cm) back legs. Twist the legs. Pass the pipe cleaner over the tail and between the back legs, then wrap it tightly around the torso towards the neck. Wrap once loosely around the neck. Wrap the body again, moving towards the tail. Wrap loosely to create a fluffy look.

6

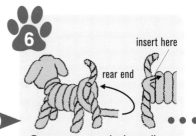

rear end insert here

Once you reach the tail, pass the pipe cleaner over the tail and through the back legs. Bend the tip slightly, apply a drop of glue, and insert it into the torso.

7 ALL DONE!

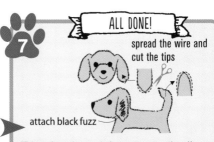

spread the wire and cut the tips attach black fuzz

Trim the tips of the ears and tail, paint eye whites on the eyes, and attach the eyes, nose, and mouth with glue. (see p. 79 for eyes and p. 74 for mouth). Glue some black pipe cleaner fluff to the outside of the ears. Bend the front and back legs slightly, adjust the body shape, and you're done!

How to Make the Miniature Dachshund

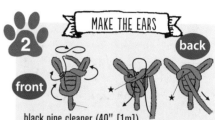

ACTUAL SIZE

Model No. 31 (page 18)

Make a two-tone dachshund with a beige nose and legs.

MATERIALS
Model No. 31 (page 18)
- One 6mm black pipe cleaner, approx. 40" (1m)
- Two 6mm beige pipe cleaners, approx. 12" (30cm)
- Two 3.5mm toy eyes
- One 4mm bear nose

All pipe cleaners used should be 40" (1m) long unless otherwise noted.

1 — MAKE THE LEGS

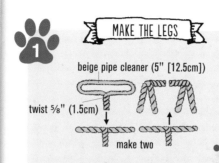

beige pipe cleaner (5" [12.5cm])

twist ⅝" (1.5cm)

make two

Cut the beige pipe cleaner into two 5" (12.5cm) sections and bend them as shown to make two sets of legs.

2 — MAKE THE EARS

back

front

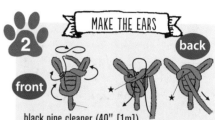

black pipe cleaner (40" [1m])

Make the head from black pipe cleaner as shown in step 1 on the previous page. Bring the pipe cleaner around from the back to the front and wrap it around the ears in a figure eight. Pass it under the diagonal portion (★) and pull it down.

3 — MAKE THE NOSE

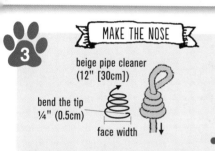

beige pipe cleaner (12" [30cm])

bend the tip ¼" (0.5cm)

face width

Bend the tip of the second beige pipe cleaner ¼" (0.5cm), then coil it as shown. Wrap it four times, then insert the pipe cleaner into the center of the coil and pull it through, taking care not to pull too hard.

4

coil 4 times

twist together

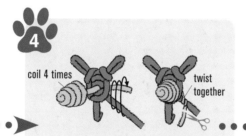

Insert the nose into the front of the face, and twist it with the black pipe cleaner coming out of the head. Cut off the excess beige pipe cleaner to use as eyebrows.

5 — MAKE THE BODY

1" (2.5cm)

¾" (2cm)

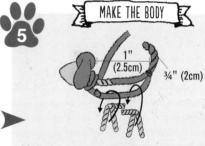

Use the black pipe cleaner coming out of the back of the head to make the body (see step 4 on the previous page). Then wrap twice around the neck and set the body on top of the legs made in step 1.

6

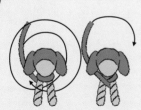

Attach the front legs by wrapping in a V shape as shown. Then wrap the pipe cleaner loosely around the torso from neck to tail to create a fluffy body.

7

insert here

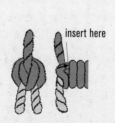

Once you reach the tail, wrap in another V shape to attach the back legs. Bend the tip of the pipe cleaner slightly, apply a drop of glue, and insert it into the torso. Extra pipe cleaner fluff will be used to color the bridge of the nose.

8 — ALL DONE!

spread wire and trim fuzz

glue beige fuzz

glue black fuzz

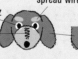
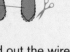

For the ears, spread out the wires and trim the points. Use glue to add eyes with painted eye whites (see p. 79). Use beige pipe cleaner fuzz to make eyebrows and black pipe cleaner fuzz on the bridge of the nose. Bend the front and back legs slightly, adjust the body shape, and you're done!

How to Make the Miniature Dachshund Puppy

Model No. 26 (page 18)

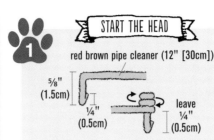

> ACTUAL SIZE

Use 3mm pipe cleaner to make puppy versions of both adult dachshunds.

MATERIALS

Model No. 26 (page 18)
- Three 3mm red brown pipe cleaners, approx. 12" (30cm)
- Two 3mm toy eyes
- Black felt for nose

How to Make the Other Models (page 18)

- **Model No. 29**
Make the same way as No. 27, using beige pipe cleaner. Make eyes with pieces of black pipe cleaner (see p. 75).

- **Model No. 32** (instructions below)
 - Two 3mm black pipe cleaners, approx. 12" (30cm)
 - One 3mm beige pipe cleaner, approx 12" (30cm)
 - Two 3mm toy eyes
 - Black felt for nose

Use 12" (30cm) 3mm pipe cleaners for the puppies. Be careful not to hurt yourself on the ends of the wires.

1 START THE HEAD

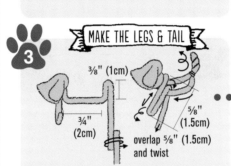

red brown pipe cleaner (12" [30cm])

⅝" (1.5cm)
¼" (0.5cm)
leave ¼" (0.5cm)

Bend the tip of the red brown pipe cleaner ¼" (0.5cm), then bend it at ⅝" (1.5cm). Using the bent part as the core, wrap the pipe cleaner around the core two and a half times from the top down. Leave about ¼" (0.5cm) at the bottom.

2 MAKE THE HEAD & EARS

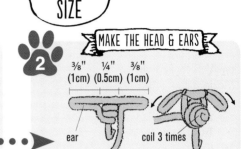

⅜" (1cm) ¼" (0.5cm) ⅜" (1cm)

ear coil 3 times

Bend as shown, then twist twice at the base of the ears. Wrap the pipe cleaner around to the back and push it through to the front. Coil three times to make the nose, then wrap the pipe cleaner around the ears in a figure eight. Pass it under the diagonal portion on the back of the head and pull it down (see steps 1–4 p. 56).

3 MAKE THE LEGS & TAIL

⅜" (1cm)
¾" (2cm)
⅝" (1.5cm)
overlap ⅝" (1.5cm) and twist

Bend the pipe cleaner coming out of the back of the head as shown, twisting a ⅜" (1cm) section for the tail. Twist another red brown pipe cleaner together with the first one, bring it up along the torso to the neck, wrap tightly twice, and make two ⅝" (1.5cm) front legs.

4 ALL DONE!

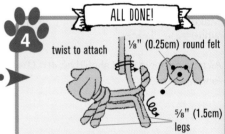

twist to attach ⅛" (0.25cm) round felt
⅝" (1.5cm) legs

Bring the pipe cleaner along the torso to the tail and make two ⅝" (1.5cm) back legs. Connect another red brown pipe cleaner to the end and wrap the body from the tail to the head and back (see steps 5–6 p. 56). Cut off the excess. Attach the eyes and nose, adjust the body, and you're done!

Two-tone Miniature Dachsund Puppy

Model No. 32 (page 18)

1 MAKE THE LEGS

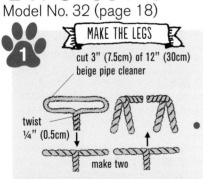

cut 3" (7.5cm) of 12" (30cm) beige pipe cleaner

twist ¼" (0.5cm)

make two

Cut the beige pipe cleaner into four 3" (7.5cm) pieces and bend them to make the two sets of legs as shown.

2 MAKE THE HEAD

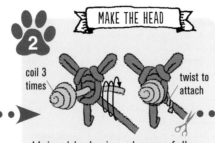

coil 3 times twist to attach

Using black pipe cleaner, follow the measurements used in steps 1–2 above to make the head. Refer to steps 3–4 p. 57 to make the nose with beige pipe cleaner, and cut off the excess.

3 ALL DONE!

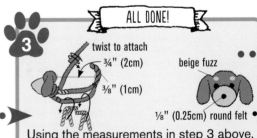

twist to attach
¾" (2cm)
⅜" (1cm)
⅛" (0.25cm) round felt
beige fuzz

Using the measurements in step 3 above, make the torso, connect additional black pipe cleaners, and attach the legs using steps 6–7 p. 57. Glue on eyes and a felt nose and use beige pipe cleaner fuzz for the eyebrows. Adjust the body shape, and you're done!

How to Make the Pomeranian

Model No. 48 (page 23)

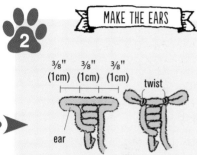

ACTUAL SIZE

The fluffy tail is the main feature. Make the body with a rounded shape in mind.

LONGMOGOL DOG ★ POMERANIAN

MATERIALS
Model No. 48 (page 23)
- One 6mm beige pipe cleaner, approx. 40" (1m)
- Two 3mm toy eyes
- One 4mm toy eye for nose

How to Make the Other Models (page 23)

- **Model No. 46**

Make the same way as No. 48, using black pipe cleaner, and paint on eye whites (see p. 79).

- **Model No. 47**

Make the same way as No. 48, using white pipe cleaner.

All pipe cleaners used should be 40" (1m) long unless otherwise noted.

1 START THE HEAD

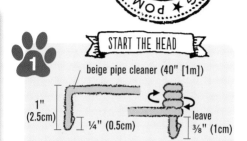

beige pipe cleaner (40" [1m])

1" (2.5cm) ¼" (0.5cm) leave ⅜" (1cm)

Bend the tip of the beige pipe cleaner ¼" (0.5cm), then bend it at 1" (2.5cm). Using the bent part as the core, wrap the pipe cleaner around the core three and a half times from the top down. Leave about ⅜" (1cm) at the bottom.

2 MAKE THE EARS

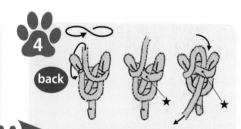

⅜" (1cm) ⅜" (1cm) ⅜" (1cm) twist

ear

Bend as shown, then twist twice at the base of the ears.

3 MAKE THE NOSE

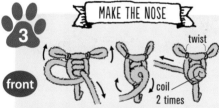

front twist coil 2 times

Wrap the pipe cleaner around to the back and push it through to the front. Pull until there is no slack. Coil the pipe cleaner loosely two times to make the lower half of the face. Insert the pipe cleaner into the center of the coil and pull it tight from behind, taking care not to pull too hard.

4

back ★ ★

Turn the head around and wrap the pipe cleaner over the right ear, then the left ear, making a figure eight. Pass it under the diagonal portion (★) and pull it down. Look at the face from the front and adjust the shape.

5 MAKE THE TAIL & LEGS

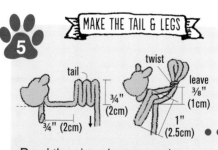

tail twist leave ⅜" (1cm) ¾" (2cm) 1" (2.5cm) ¾" (2cm)

Bend the pipe cleaner coming out of the back of the head as shown. Twist the three ¾" (2cm) sections together at the base to make the tail, creating a fluffy look. Bring the pipe cleaner forward to the neck and wrap tightly twice. Include the core piece when wrapping. Create two 1" (2.5cm) front legs as shown.

6 MAKE THE BODY

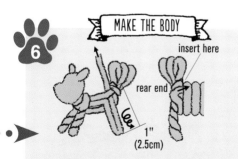

insert here rear end 1" (2.5cm)

Twist both front legs, then bring the pipe cleaner along the torso to the tail and make two 1" (2.5cm) back legs. Twist the back legs. Wrap the pipe cleaner around the body from tail to neck and back. See steps 11–18 p. 38 for details on making legs, wrapping the body, and hiding the end of the pipe cleaner.

7 ALL DONE!

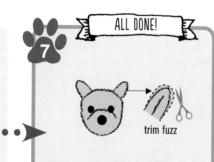

trim fuzz

Trim the tips of the ears and glue on the eyes and nose. Adjust the body shape, and you're done!

How to Make the French Bulldog

Model No. 39 (page 21)

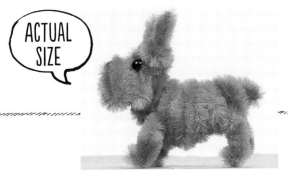

ACTUAL SIZE

This adaptation of the toy poodle design allows an entire dog to be made with a single pipe cleaner.

MATERIALS
Model No. 39 (page 21)
- One 6mm beige pipe cleaner, approx. 40" (1m)
- Two 3.5mm toy eyes
- One 4.5mm bear nose

How to Make the Other Models (page 21)

- **Model No. 40**
Make the same way as No. 39, but use copper pipe cleaner.

- **Model No. 41**
Make the same way as No. 39, but use white pipe cleaner.

- **Model No. 42**
 - One 6mm white pipe cleaner, approx. 40" (1m)
 - One 6mm black pipe cleaner, approx. 12" (30cm)

To make No. 42, make up to step 2 on this page, then refer to steps 3–7 p. 43 (Boston Terrier) to make the head. Using the white pipe cleaner coming from the head, start from step 8 p. 61 to make the body. Cut some fuzz from a black pipe cleaner to make spots. Paint eye whites on the eyes (see p. 79).

All pipe cleaners used should be 40" (1m) long unless otherwise noted.

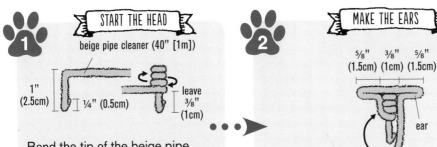

1 START THE HEAD

beige pipe cleaner (40" [1m])

1" (2.5cm) ¼" (0.5cm) leave ⅜" (1cm)

Bend the tip of the beige pipe cleaner ¼" (0.5cm), then bend it at 1" (2.5cm). Using the bent part as the core, wrap the pipe cleaner around the core three and a half times from the top down. Leave about ⅜" (1cm) at the bottom.

2 MAKE THE EARS

⅝" (1.5cm) ⅜" (1cm) ⅝" (1.5cm)

ear

Bend as shown, then twist twice at the base of the ears.

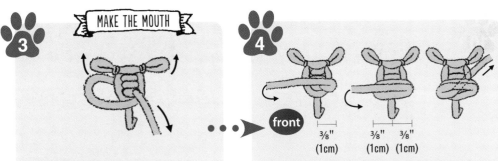

3 MAKE THE MOUTH

Wrap the pipe cleaner around to the back and push it through to the front. Pull until there is no slack.

4

front

⅜" (1cm) ⅜" (1cm) ⅜" (1cm)

Wrap the pipe cleaner loosely twice as shown to make the lower half of the face. Insert the pipe cleaner into the center of the nose and pull it tight from behind, taking care not to pull too hard.

5

back

Turn the head around and wrap the pipe cleaner around the ears in a figure eight.

6

back

Pass the pipe cleaner under the diagonal portion (★) and pull it down.

LONGMOGOL DOG ★ FRENCH BULLDOG ★

CONTINUED

7 Turn the head to the front and bend the corners of the mouth down, giving the face a slightly squished appearance.

front

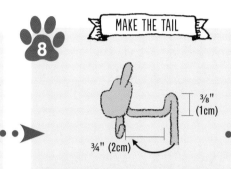

MAKE THE TAIL

8 Bend the pipe cleaner coming out of the back of the head as shown. Twist the 3/8" (1cm) section to make the tail.

3/8" (1cm)
3/4" (2cm)

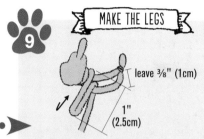

MAKE THE LEGS

9 Bring the pipe cleaner forward to the neck and wrap tightly twice. Include the core piece when wrapping. Bend the pipe cleaner to make a 1" (2.5cm) leg, pass it through the torso, and make a second leg on the other side.

leave 3/8" (1cm)
1" (2.5cm)

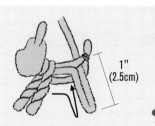

10 Twist both legs. Bring the pipe cleaner along the torso to the tail, make a 1" (2.5cm) back leg, and pass the pipe cleaner through the torso to the other side.

1" (2.5cm)

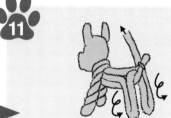

11 Make another leg on the other side, then twist both legs.

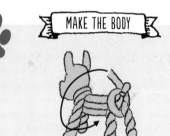

MAKE THE BODY

12 Pass the pipe cleaner over the tail and between the legs and wrap it tightly around the torso towards the neck.

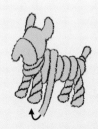

13 Wrap it loosely once around the neck, then wrap the body again, moving towards the tail. Wrap loosely to create a fluffy look.

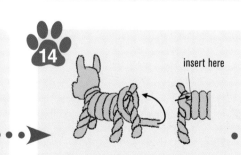

14 Pass the pipe cleaner over the tail and down through the legs. Bend the tip slightly, apply a drop of glue, and insert it into the torso.

insert here

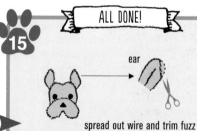

ALL DONE!

ear
spread out wire and trim fuzz

15 Trim the ears and glue on the eyes and nose. Bend the tips of the legs slightly, adjust the body shape, and you're done!

How to Make the Shih Tzu

Model No. 43 (page 22)

This Shih Tzu has a little mohawk down his back and a different color ears and eyes.

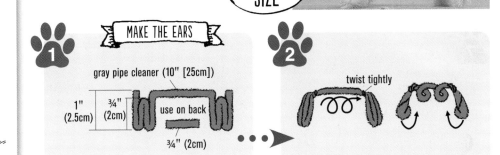

ACTUAL SIZE

MATERIALS
Model No. 43 (page 22)
- One 6mm white pipe cleaner, approx. 40" (1m)
- One 6mm gray pipe cleaner, approx 12" (30cm)
- Two 4mm toy eyes
- One 4.5mm bear nose

How to Make the Other Models (page 22)

• Model No. 44

Make the same way as No. 43, using 12" (30cm) medium brown pipe cleaner for the ears, around the eyes, and along the back. Make the eyes from black pipe cleaner (see p. 75), and make a tongue with pink felt.

• Model No. 45

Make the same way as No. 43, using 12" (30cm) beige pipe cleaner for the ears, around the eyes, and along the back.

All pipe cleaners used should be 40" (1m) long unless otherwise noted.

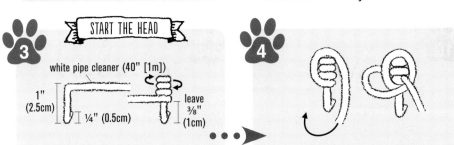

1 — MAKE THE EARS

gray pipe cleaner (10" [25cm])

1" (2.5cm) ¾" (2cm) use on back ¾" (2cm)

Cut a ¾" (2cm) length of gray pipe cleaner for the back, and fold the rest from the ends inward into the shape shown to begin making the ears.

2

twist tightly

Taking care to avoid the sharp wire tips, twist the 1" (2.5cm) sections at their bases to make the ears, then bend the ear tips inward slightly. Make two loops in the wire between the ears. This will be the area around the eyes.

3 — START THE HEAD

white pipe cleaner (40" [1m])

1" (2.5cm) ¼" (0.5cm) leave ⅜" (1cm)

Bend the tip of the white pipe cleaner ¼" (0.5cm), then bend it at 1" (2.5cm). Using the bent part as the core, wrap the pipe cleaner around the core three and a half times from the top down. Leave about ⅜" (1cm) at the bottom.

4

Bend as shown, then wrap the pipe cleaner around to the back and push it through to the front. Pull until there is no slack.

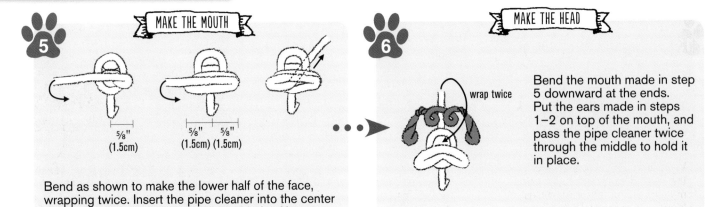

5 — MAKE THE MOUTH

⅝" (1.5cm) ⅝" (1.5cm) ⅝" (1.5cm)

Bend as shown to make the lower half of the face, wrapping twice. Insert the pipe cleaner into the center of the mouth and pull it tight from behind, taking care not to pull too hard.

6 — MAKE THE HEAD

wrap twice

Bend the mouth made in step 5 downward at the ends. Put the ears made in steps 1–2 on top of the mouth, and pass the pipe cleaner twice through the middle to hold it in place.

CONTINUED

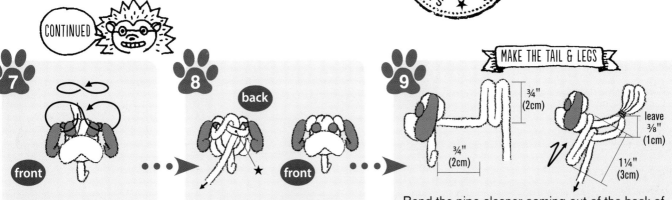

7

front

Wrap the pipe cleaner around the ears in a figure eight.

8

back

front

Turn the head around, pass the pipe cleaner under the diagonal portion (★), and pull it down.

9

MAKE THE TAIL & LEGS

¾" (2cm)

¾" (2cm)

leave ⅜" (1cm)

1¼" (3cm)

Bend the pipe cleaner coming out of the back of the head as shown and twist the ¾" (2cm) section to make the tail. Bring the pipe cleaner forward to the neck and wrap tightly twice. Include the core piece when wrapping. Bend the pipe cleaner to make a 1¼" (3cm) front leg and pass it through the torso to the other side.

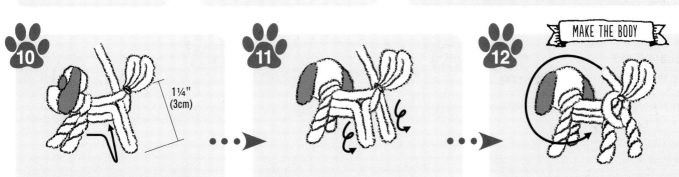

10

1¼" (3cm)

Make a second leg on the other side, then twist both legs. Bring the pipe cleaner along the torso to the tail, make a 1¼" (3cm) back leg, and pass it through the torso to the other side.

11

Make another leg on the other side, then twist both legs.

12

MAKE THE BODY

Pass the pipe cleaner over the tail and between the legs and wrap it tightly around the torso towards the neck.

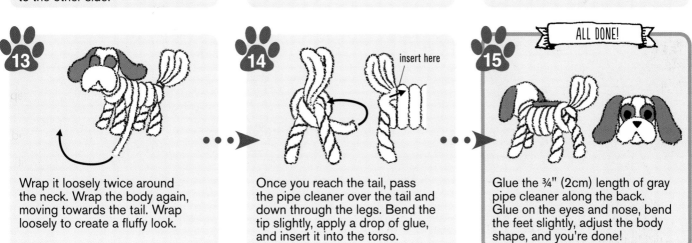

13

Wrap it loosely twice around the neck. Wrap the body again, moving towards the tail. Wrap loosely to create a fluffy look.

14

insert here

Once you reach the tail, pass the pipe cleaner over the tail and down through the legs. Bend the tip slightly, apply a drop of glue, and insert it into the torso.

15

ALL DONE!

Glue the ¾" (2cm) length of gray pipe cleaner along the back. Glue on the eyes and nose, bend the feet slightly, adjust the body shape, and you're done!

How to Make the Wire Fox Terrier

Model No. 49 (page 24)

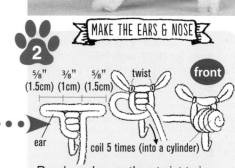

ACTUAL SIZE

This terrier's face is fluffy and cylindrical. Use two colors, with variations on the torso color.

MATERIALS
Model No. 49 (page 24)
- One 6mm ivory pipe cleaner, approx. 40" (1m)
- One 6mm beige pipe cleaner. approx. 12" (30cm)
- Two 3mm toy eyes
- One 4.5mm bear nose

How to Make the Other Model (page 24)

- Model No. 51

Make the same way as No. 49, using 12" (30cm) gray pipe cleaner for the torso and tail.

All pipe cleaners used should be 40" (1m) long unless otherwise noted.

1 START THE HEAD

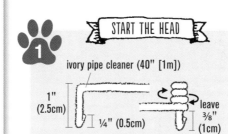

ivory pipe cleaner (40" [1m])

1" (2.5cm) ¼" (0.5cm) leave ⅜" (1cm)

Bend the tip of the ivory pipe cleaner ¼" (0.5cm), then bend it at 1" (2.5cm). Using the bent part as the core, wrap the pipe cleaner around the core three and a half times from the top down. Leave about ⅜" (1cm) at the bottom.

2 MAKE THE EARS & NOSE

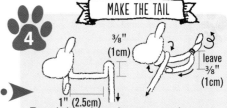

⅝" (1.5cm) ⅜" (1cm) ⅝" (1.5cm) twist front

ear coil 5 times (into a cylinder)

Bend as shown, then twist twice at the base of the ears. Wrap the pipe cleaner around to the back and push it through to the front. Coil the pipe cleaner five times for the lower half of the face, then insert it into the center of the coil and pull it tight from behind, taking care not to pull too hard.

3

back

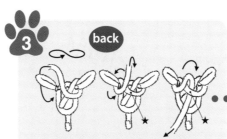

Turn the head around and wrap the pipe cleaner around the ears in a figure eight. Pass it under the diagonal portion (★) and pull it down.

4 MAKE THE TAIL

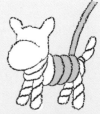

⅜" (1cm) leave ⅜" (1cm)

1" (2.5cm)

Bend the pipe cleaner coming out of the back of the head as shown. Twist a ⅜" (1cm) section for the tail. Bring the pipe cleaner forward to the neck and wrap tightly twice. Include the core piece when wrapping.

5 MAKE THE LEGS

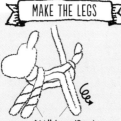

1¼" legs (3cm)

Bend the pipe cleaner to make a 1¼" (3cm) leg, pass it through the torso, and make another leg on the other side. Then twist both front legs. Bring the pipe cleaner along the torso to the tail and create two more 1¼" (3cm) legs.

6 MAKE THE BODY

Pass the pipe cleaner over the tail and between the legs and wrap it tightly around the torso towards the neck. Then wrap it loosely twice around the neck. Next, wrap it loosely twice around the chest and cut off the excess. Apply a drop of glue on the tip and insert it into the torso.

7

Put some glue on the tip of the beige pipe cleaner and insert it into the torso. Wrap it loosely around the torso towards the tail to create a fluffy look.

How to Make the Wire Fox Terrier

Model No. 50 (page 24)

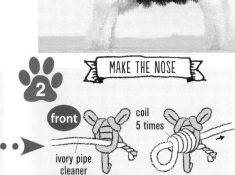

ACTUAL SIZE

Use three colors of pipe cleaner for a different color head, body, and rear.

MATERIALS

Model No. 50 (page 24)

- One 6mm ivory pipe cleaner, approx. 40" (1m)
- One 6mm beige pipe cleaner, approx. 12" (30cm)
- One 6mm black pipe cleaner, approx. 12" (30cm)
- Two 3mm toy eyes
- One 4.5mm bear nose

All pipe cleaners used should be 40" (1m) long unless otherwise noted.

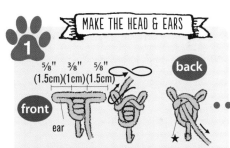

1 MAKE THE HEAD & EARS

⅝" ⅜" ⅝"
(1.5cm)(1cm)(1.5cm)

front

ear

back

Using the beige pipe cleaner, make the head and ears using the same measurements as steps 1–2 on the previous page. Bring the pipe cleaner around from the back and wrap it around the ears in a figure eight. Turn the head around and pass the pipe cleaner under the diagonal portion (★), pulling it down tightly.

2 MAKE THE NOSE

front

coil 5 times

ivory pipe cleaner (40" [1m])

Push the ivory pipe cleaner through from the front to the back and twist the end together with the end of the beige pipe cleaner. Coil the ivory pipe cleaner loosely five times to make the lower half of the face, insert it into the center of the coil, and pull it tight from behind, taking care not to pull too hard.

3 MAKE THE TAIL

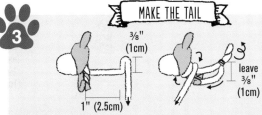

⅜" (1cm)

leave ⅜" (1cm)

1" (2.5cm)

Bend the pipe cleaner coming out of the back of the head as shown. Twist the ⅜" (1cm) section to make the tail. Bring the pipe cleaner forward to the neck and wrap tightly twice. Include the core piece when wrapping.

4 ALL DONE!

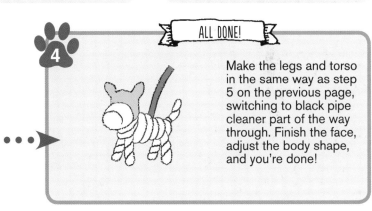

Make the legs and torso in the same way as step 5 on the previous page, switching to black pipe cleaner part of the way through. Finish the face, adjust the body shape, and you're done!

8

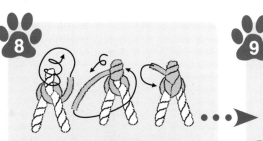

Once you reach the tail, pass the pipe cleaner over the tail and down through the legs. Wrap it around the tail from top to bottom to conceal the ivory color. Wrap it twice from the bottom of the torso through the back legs to make a V shape.

9

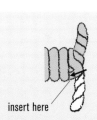

insert here

Bend the tip of the pipe cleaner slightly, apply a drop of glue, and insert it into the torso.

10 ALL DONE!

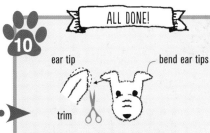

ear tip

bend ear tips

trim

Cut the tips of the ears and bend them forward. Glue on the eyes and nose. Bend the feet slightly, adjust the body shape, and you're done!

How to Make the Jack Russell Terrier

Model No. 54 (page 25)

Make variations with different head colors. Create a mischievous face.

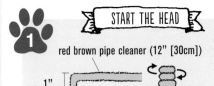

ACTUAL SIZE

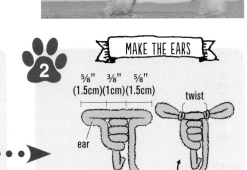

MATERIALS
Model No. 54 (page 25)
- One 6mm ivory pipe cleaner, approx. 40" (1m)
- One 6mm red brown pipe cleaner, approx. 12" (30cm)
- Two 3.5mm toy eyes
- One 4.5mm bear nose

How to Make the Other Models (page 25)

- Model No. 52

Make the same way as No. 54, and change the color of the head and ears using 12" (30cm) copper pipe cleaner instead of red brown. Cut some fuzz to glue on the base of the tail.

- Model No. 53

Make the same way as No. 54, and change the color of the head and ears using 12" (30cm) copper pipe cleaner instead of red brown. Use black pipe cleaner for the eyes (see p. 75).

All pipe cleaners used should be 40" (1m) long unless otherwise noted.

START THE HEAD

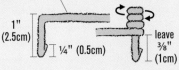

red brown pipe cleaner (12" [30cm])

1" (2.5cm) ¼" (0.5cm) leave ⅜" (1cm)

Bend the tip of the red brown pipe cleaner ¼" (0.5cm), then bend it at 1" (2.5cm). Using the bent part as the core, wrap the pipe cleaner around the core three and a half times from the top down. Leave about ⅜" (1cm) at the bottom.

MAKE THE EARS

⅝" ⅜" ⅝"
(1.5cm)(1cm)(1.5cm)

twist

ear

Bend as shown, then twist twice at the base of the ears. Wrap the pipe cleaner around to the back.

3

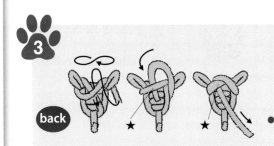

back

Turn the head around and wrap the pipe cleaner around the ears in a figure eight. Pass it under the diagonal portion (★) and pull it down.

4

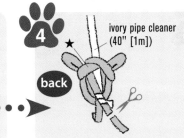

ivory pipe cleaner (40" [1m])

back

Insert the ivory pipe cleaner into the ★ and twist it together with the red brown pipe cleaner. Trim them so they are the same length as the head core.

5 MAKE THE NOSE

front

Bring the ivory pipe cleaner down the center of the face, and bend it as shown to start the lower half of the face.

6

coil 3 times

Coil it three times, then insert it into the center of the coil and pull it tight from behind, taking care not to pull too hard. Adjust the shape of the nose.

7 MAKE THE TAIL

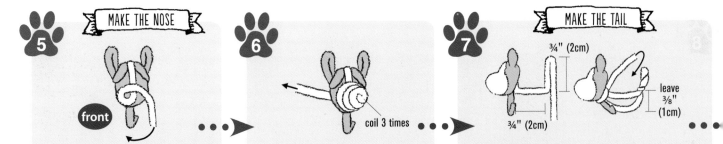

¾" (2cm)

¾" (2cm)

leave ⅜" (1cm)

Bend the pipe cleaner coming out of the back of the head as shown. Twist the ¾" (2cm) section to make the tail. Bring the pipe cleaner forward to the neck and wrap tightly twice. Include the core piece when wrapping.

How to Make the Jack Russell Terrier Puppy

Model No. 55 (page 25)

ACTUAL SIZE

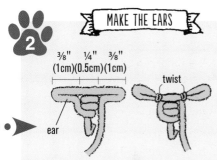

Make a puppy small enough to fit on a teaspoon with 3mm pipe cleaner.

MATERIALS
Model No. 55 (page 25)
- One 3mm ivory pipe cleaner, approx. 12" (30cm)
- One 3mm red brown pipe cleaner, approx. 12" (30cm)
- Two 3mm toy eyes
- Black felt for nose

Use 12" (30cm) 3mm pipe cleaners for the puppies. Be careful not to hurt yourself on the ends of the wires.

1 START THE HEAD

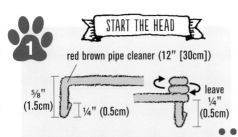

red brown pipe cleaner (12" [30cm])

⅝" (1.5cm) ¼" (0.5cm) leave ¼" (0.5cm)

Bend the tip of the red brown pipe cleaner ¼" (0.5cm), then bend it at ⅝" (1.5cm). Using the bent part as the core, wrap the pipe cleaner around the core two and a half times from the top down. Leave about ¼" (0.5cm) at the bottom.

2 MAKE THE EARS

⅜" ¼" ⅜"
(1cm)(0.5cm)(1cm)

twist

ear

Bend as shown, then twist twice at the base of the ears.

3 MAKE THE NOSE

ivory pipe cleaner (12" [30cm])

back ★

Follow steps 3–6 on the previous page to make the head.

4 MAKE THE TAIL & LEGS

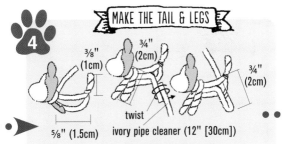

⅜" (1cm) ¾" (2cm) ¾" (2cm)

twist

⅝" (1.5cm) ivory pipe cleaner (12" [30cm])

Create the tail and body using the measurements above. Partway through you will need to twist on another ivory pipe cleaner (overlap about ⅝" [1.5cm]). Make ¾" (2cm) legs (see steps 11–14 p. 38).

5 ALL DONE!

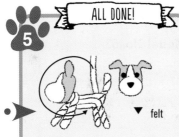

▼ felt

Wrap the torso from tail to neck and back and cut off the excess to make the body (as in step 8 below). Glue on the eyes and felt nose, adjust the body shape, and you're done!

8 MAKE THE LEGS & BODY

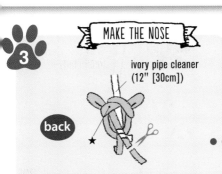

1¼" (3cm)

insert here

Make four 1¼" (3cm) legs (see steps 11–14 p. 38) and wrap the torso tightly from tail to neck. Then wrap the pipe cleaner loosely twice around the neck, and wrap the body again, moving towards the tail. Wrap loosely to create a fluffy look. Cut off any excess pipe cleaner, apply a drop of glue to the tip, and insert it into the torso.

9 ALL DONE!

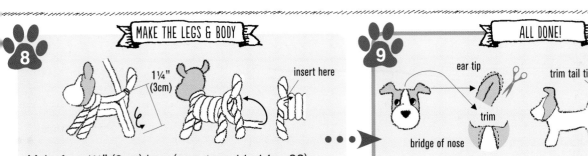

ear tip trim tail tip

trim

bridge of nose

LEMON HEDGEHOG (LITTLE SISTER)

Trim the tips of the ears and tail and the bridge of the nose, and glue on the nose and eyes with painted eye whites (see p. 79). Bend the tips of the ears and the feet slightly, adjust the body shape, and you're done!

How to Make the Italian Greyhound

Model No. 58 (page 26)

Make a noble little Italian Greyhound with a white stripe going from his nose down his neck to his belly.

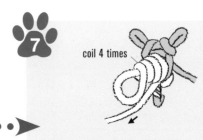

ACTUAL SIZE

MATERIALS
Model No. 58 (page 26)
- One 6mm medium brown pipe cleaner, approx. 40" (1m)
- One 6mm white pipe cleaner, approx. 12" (30cm)
- Two 4mm toy eyes
- One 4.5mm toy eye for nose

How to Make the Other Models (page 26)

- Model No. 56
 - One light pink pipe cleaner, approx. 40" (1m)
 - One white pipe cleaner, approx. 12" (30cm)

- Model No. 57
 - One gray pipe cleaner, approx. 40" (1m)
 - One white pipe cleaner, approx. 12" (30cm)
 Paint on eye whites (see p. 79).

- Model No. 59
 - One copper pipe cleaner, approx. 40" (1m)
 - One beige pipe cleaner, approx. 12" (30cm)

All pipe cleaners used should be 40" (1m) long unless otherwise noted.

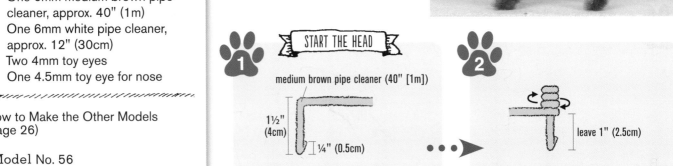

1 START THE HEAD

medium brown pipe cleaner (40" [1m])

1½" (4cm) ¼" (0.5cm)

Bend the tip of the medium brown pipe cleaner ¼" (0.5cm), then bend it at 1½" (4cm).

2

leave 1" (2.5cm)

Using the bent part as the core, wrap the pipe cleaner around the core three and a half times from the top down. Leave about 1" (2.5cm) at the bottom.

3 MAKE THE EARS

⅜" (1cm) ⅜" (1cm) ⅜" (1cm)

ear

Bend as shown, then twist twice at the base of the ears.

4

front

Wrap the pipe cleaner around to the back and wrap it around the ears in a figure eight.

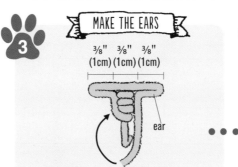

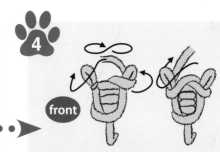

5

back

Turn the head around, pass the pipe cleaner under the diagonal portion (★), and pull it down.

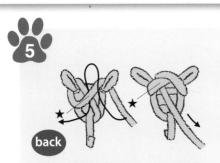

6 MAKE THE NOSE

front

white pipe cleaner (12" [30cm])

Insert the white pipe cleaner at the bottom of the front of the head and twist it together with the medium brown head core.

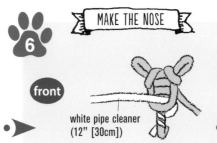

7

coil 4 times

Coil the white pipe cleaner loosely four times, then insert it into the center of the coil and pull it tight from behind. Shape the nose to make it slightly pointed, and apply some glue to the base of the coil to secure it to the face.

Making Pipe Cleaner Pets

CHI HEDGEHOG AND CHI'S MOM

CONTINUED

8 MAKE THE TAIL

⅝" (1.5cm)

¾" (2cm)

1" (2.5cm)

Bend the medium brown pipe cleaner coming out of the back of the head as shown. Twist the ¾" (2cm) section to make the tail.

9

leave ⅜" (1cm)

Bring the pipe cleaner forward to the neck and wrap it tightly twice, diagonally and upwards.

10 MAKE THE LEGS

1⅜" (3.5cm)

Make a 1⅜" (3.5cm) leg and pass the pipe cleaner through the torso to the other side.

11

1⅜" (3.5cm)

Make a second leg on the other side, then twist both legs. Bring the pipe cleaner along to the torso to the tail, make a 1⅜" (3.5cm) back leg, and pass the pipe cleaner through the torso to the other side.

12 MAKE THE BODY

Make another leg on the other side, then twist both legs. Wrap the pipe cleaner tightly around the torso towards the neck.

13

Wrap loosely once around the neck, then wrap the body again, moving towards the tail. Wrap loosely to create a fluffy look. Once you reach the tail, wrap once between the legs, bend the tip of the pipe cleaner, apply a drop of glue, and insert it into the torso.

14

Bend the white pipe cleaner coming out of the face down the neck and along the belly. Cut it just below the tail. Trim fuzz from the extra pipe cleaner to use on the bridge of the nose.

15

Bend the tip of the white pipe cleaner, apply a drop of glue, and insert it into the torso.

16 ALL DONE!

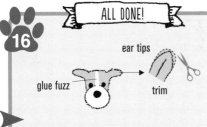

ear tips

glue fuzz

trim

Trim the tips of the ears and glue on the eyes and nose. Glue some white pipe cleaner fuzz to the bridge of the nose. Bend the tips of the ears and feet slightly, adjust the body shape, and you're done!

How to Make the Labrador Retriever

Model No. 66 (page 29)

The sturdy legs are a unique feature of this dog. Make this big guy with two long pipe cleaners.

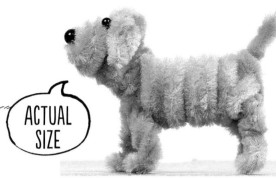

ACTUAL SIZE

MATERIALS
Model No. 66 (page 29)
- Two 6mm beige pipe cleaners, approx. 40" (1m)
- Two 3mm toy eyes
- One 4.5mm toy eye for nose

How to Make the Other Models (page 29)

- **Model No. 64**
Make the same way as No. 66, using white pipe cleaner, and use thick black thread for the mouth (see p. 74).

- **Model No. 65**
Make the same way as No. 66, using black pipe cleaner, and paint on eye whites (see p. 79).

All pipe cleaners used should be 40" (1m) long unless otherwise noted.

1 START THE HEAD
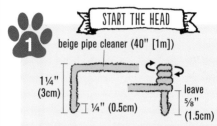
beige pipe cleaner (40" [1m])

1¼" (3cm)
¼" (0.5cm)
leave 5/8" (1.5cm)

Bend the tip of the beige pipe cleaner ¼" (0.5cm), then bend it at 1¼" (3cm). Using the bent part as the core, wrap the pipe cleaner around the core three and a half times from the top down. Leave about 5/8" (1.5cm) at the bottom.

2 MAKE THE EARS
¾" (2cm) ⅜" (1cm) ¾" (2cm)
twist
ear

Bend as shown, then twist twice at the base of the ears.

3 MAKE THE NOSE

Wrap the pipe cleaner around to the back and push it through to the front. Pull until there is no slack.

4
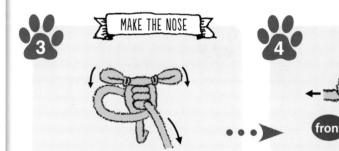
front

Coil the pipe cleaner loosely three times to make the lower half of the face. Insert the pipe cleaner into the center of the coil and pull it tight from behind, taking care not to pull too hard.

5
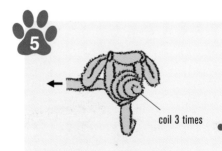
coil 3 times

Work the nose into shape.

6
back

Turn the head around and wrap the pipe cleaner around the right ear.

7
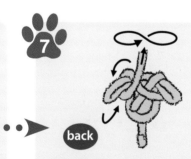
back

Then wrap it around the left ear, making a figure eight.

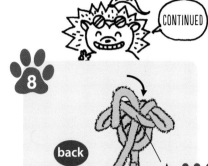

 8

back

Pass the pipe cleaner under the diagonal portion (★) and pull it down. Look at the head from the front, and adjust the face, head, and ears.

9 MAKE THE TAIL

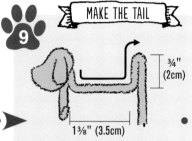

¾" (2cm)

1⅜" (3.5cm)

Bend the pipe cleaner coming out of the back of the head as shown. Twist the ¾" (2cm) section to make the tail.

10 MAKE THE LEGS

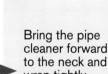

leave ⅜" (1cm)

1½" (4cm)

Bring the pipe cleaner forward to the neck and wrap tightly twice. Make a 1½" (4cm) front leg, pass the pipe cleaner through the torso, and make another 1½" (4cm) leg on the same side. One leg will be four pipe cleaners thick. Then pass the pipe cleaner through the torso again.

11

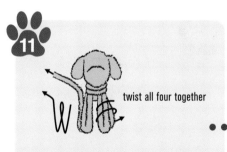

twist all four together

Make the same four-pronged leg on the other side, then twist each set of four together to make the front legs.

12

overlap ¾" (2cm) and twist

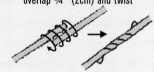

Twist on another pipe cleaner when necessary, overlapping them by about ¾" (2cm) and twisting together. Take care not to hurt yourself on the ends of the wires.

13

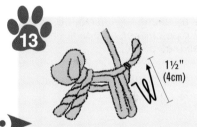

1½" (4cm)

Bring the pipe cleaner along the torso to the tail, make a 1½" (4cm) back leg, pass the pipe cleaner through the torso, and make another 1½" (4cm) leg on the same side. Again, one leg will be four pipe cleaners thick.

14

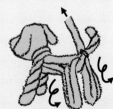

twist all four together

Make the same four-pronged leg on the other side, then twist each set of four together to make the back legs.

15

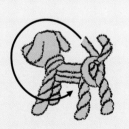

Pass the pipe cleaner over the tail and between the legs and wrap it tightly around the torso towards the neck.

16 MAKE THE BODY

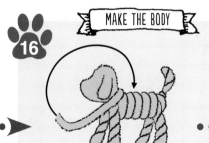

Wrap it loosely twice around the neck.

Continued on the top of p. 72

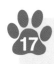

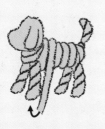

17

Wrap the body again, moving towards the tail. Wrap loosely to create a fluffy look.

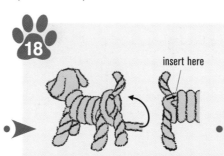

18

insert here

Once you reach the tail, pass the pipe cleaner over the tail and down through the legs. Cut off any excess, apply a drop of glue to the tip, and insert it into the torso.

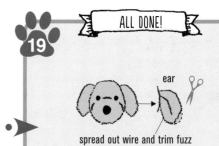

19 ALL DONE!

ear

spread out wire and trim fuzz

Trim the tips of the ears, glue on the eyes and nose, bend the tips of the legs slightly, adjust the body shape, and you're done!

How to Make the Old English Sheepdog

Model No. 82 (page 35)

Make a sturdy body from 6mm pipe cleaners, and use 3mm pipe cleaners to make a fluffy coat of fur.

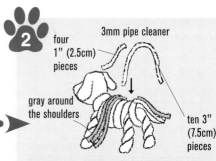

ACTUAL SIZE

MATERIALS
Model No. 82 (page 35)
- Two 6mm white pipe cleaners, approx. 40" (1m)
- Three 6mm white pipe cleaners, approx. 12" (30cm)
- Two 6mm gray pipe cleaners, approx. 12" (30cm)
- Two 3mm toy eyes
- One 4.5mm toy eye for nose

All pipe cleaners used should be 40" (1m) long unless otherwise noted.

1 MAKE THE BODY

one gray
3mm pipe cleaner
(1¼" [3cm])
two white

Use the labrador retriever instructions (p. 70) to make the body from the 6mm white pipe cleaner, then cut lengths of white and gray 3mm pipe cleaner to attach to the back. Start by attaching three pieces to the tail.

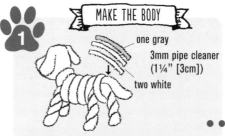

2

four 1" (2.5cm) pieces

3mm pipe cleaner

gray around the shoulders

ten 3" (7.5cm) pieces

Apply some glue to the back of the dog, and lay white and gray 3mm pieces across the back. Make the pieces somewhat long, as they can be trimmed afterwards.

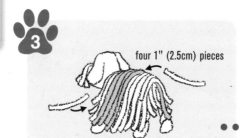

3

four 1" (2.5cm) pieces

Put glue on the tips of a few smaller lengths of 3mm pipe cleaner, and insert them anywhere on the body.

4 ALL DONE!

3mm white pipe cleaner:
two 2" (5cm)
two ⅝" (1.5cm)

Glue some 3mm pipe cleaner pieces to the space between the nose and eyes. Bend the feet slightly, adjust the body shape, and you're done!

How to Make the Pembroke Welsh Corgi

Model No. 62 (page 28)

ACTUAL SIZE

This breed has short legs on a stocky body. Use two colors of pipe cleaner with different colors on the back and belly.

MATERIALS
Model No. 62 (page 28)

- One 6mm ivory pipe cleaner, approx. 40" (1m)
- One 6mm copper pipe cleaner, approx. 40" (1m)
- Two 3mm toy eyes
- One 4.5mm toy eye for nose

How to Make the Other Model (page 28)

- Model No. 63

Make the same way as No. 62, using beige pipe cleaner for the ears, cheeks, and back.

All pipe cleaners used should be 40" (1m) long unless otherwise noted.

1 START THE HEAD

copper pipe cleaner (40" [1m])

1" (2.5cm)

¼" (0.5cm)

leave ³⁄₈" (1cm)

Bend the tip of the coppr pipe cleaner ¼" (0.5cm), then bend it at 1" (2.5cm). Using the bent part as the core, wrap the pipe cleaner around the core three and a half times from the top down. Leave about ³⁄₈" (1cm) at the bottom.

2 MAKE THE EARS

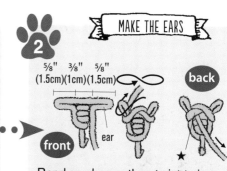

⅝" (1.5cm) ³⁄₈" (1cm) ⅝" (1.5cm)

front ear back

Bend as shown, then twist twice at the base of the ears. Wrap the pipe cleaner around to the back and wrap it around the ears in a figure eight. Pass the pipe cleaner under the diagonal portion (★) and pull it down.

3 MAKE THE NOSE

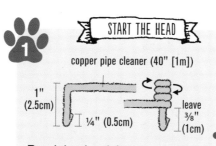

ivory pipe cleaner (40" [1m])

back front coil 4 times

Insert the ivory pipe cleaner at the ★ and twist it together with the copper pipe cleaner. Bring the ivory pipe cleaner down the center of the face and coil it four times as shown. Then insert it into the center of the coil and pull it tight from behind, taking care not to pull too hard.

4 MAKE THE LEGS

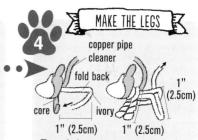

copper pipe cleaner

fold back

core ivory

1" (2.5cm)

1" (2.5cm) 1" (2.5cm)

Bend the pipe cleaner coming out of the back of the head as shown. Bring it forward to the neck and wrap tightly twice. Make 1" (2.5cm) front and back legs (see p. 38 10–14 for how to make legs).

5 MAKE THE BODY

insert

Wrap the pipe cleaner tightly around the torso from tail to neck, then wrap it loosely twice around the neck as shown to create a V. Cut off any excess pipe cleaner, bend the tip, apply a drop of glue, and insert it into the torso.

6

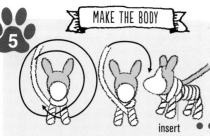

lay flat twist 2 times tail

tuck the tip inside ⅝" (1.5cm)

Drape the copper pipe cleaner on the dog's back, bending it as shown. Once you reach the tail end, twist the end of the copper pipe cleaner twice to make the tail, and push it down. Cut off any excess, apply a drop of glue to the tip, and insert it into the torso.

7 ALL DONE!

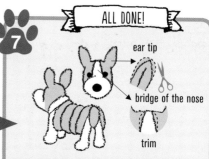

ear tip

bridge of the nose

trim

Trim the tips of the ears and the bridge of the nose and glue on the eyes and nose. Bend the tips of the legs, adjust the body shape, and you're done!

How to Make the Hokkaido

Model No. 68 (page 30)

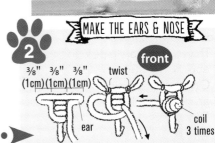

ACTUAL SIZE

Change the color of the pipe cleaner to make this into a Kai or Kishu dog. This simple design uses just one pipe cleaner.

MATERIALS
Model No. 68 (page 30)
- One 6mm ivory pipe cleaner, approx. 40" (1m)
- One 6mm light pink pipe cleaner, approx. 12" (30cm) for ears
- Two 2.5mm toy eyes
- One 4.5mm bear nose
- Thick black thread for mouth

All pipe cleaners used should be 40" (1m) long unless otherwise noted.

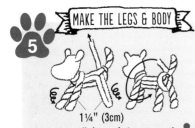

1 START THE HEAD

ivory pipe cleaner (40" [1m])

1" (2.5cm) ¼" (0.5cm) leave ⅜" (1cm)

Bend the tip of the ivory pipe cleaner ¼" (0.5cm), then bend it at 1" (2.5cm). Using the bent part as the core, wrap the pipe cleaner around the core three and a half times from the top down. Leave about ⅜" (1cm) at the bottom.

2 MAKE THE EARS & NOSE

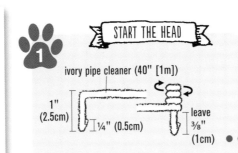

⅜" (1cm) ⅜" (1cm) ⅜" (1cm) twist **front**

ear coil 3 times

Bend as shown, then twist twice at the base of the ears. Wrap the pipe cleaner around to the back and push it through to the front. Coil it three times to make the lower half of the face. Insert the pipe cleaner into the center of the coil and pull it tight from behind, taking care not to pull too hard.

3

back

Turn the head around and wrap the pipe cleaner around the ears in a figure eight. Pass it under the diagonal portion (★) and pull it down.

4 MAKE THE TAIL

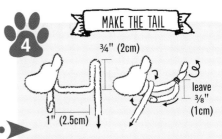

¾" (2cm) leave ⅜" (1cm)

1" (2.5cm)

Bend the pipe cleaner coming out of the back of the head as shown. Twist the ¾" (2cm) section to make the tail. Bring the pipe cleaner forward to the neck and wrap tightly twice. Include the core piece when wrapping.

5 MAKE THE LEGS & BODY

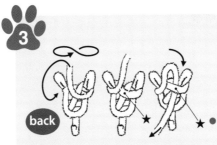

1¼" (3cm)

Make 1¼" (3cm) front and back legs. Wrap the pipe cleaner tightly from tail to neck and loosely from neck to tail to make the torso. See steps 11–18 p. 38 for how to make the legs and wrap the body.

6 ALL DONE!

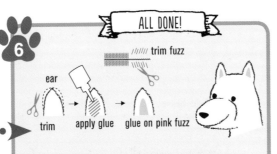

trim fuzz

ear

trim apply glue glue on pink fuzz

Trim the tips of the ears and glue pink pipe cleaner fuzz to the insides. Glue on the eyes, nose, and mouth. See the diagram to the right for how to attach the mouth. Bend the tips of the legs, adjust the body shape, and you're done!

HOW TO MAKE A THREAD MOUTH

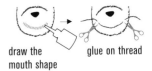

draw the mouth shape glue on thread

Apply glue to the place where you want to affix the mouth, then attach a piece of thick black thread that is longer than you want. Once the glue dries, trim off the excess thread.

How to Make the Hokkaido Puppy

Model No. 67 (page 30)

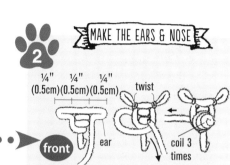

ACTUAL SIZE

To make the sleepy puppy eyes on this 3mm pipe cleaner dog, use pipe cleaner fluff arranged in a line.

MATERIALS
Model No. 67 (page 30)

- Three 3mm ivory pipe cleaners, approx. 12" (30cm)
- One 6mm light pink pipe cleaner, approx. 12" (30cm) for ears
- One 6mm black pipe cleaner, approx. 12" (30cm) for eyes
- Black felt for nose

Use 12" (30cm) 3mm pipe cleaners for the puppies. Be careful not to hurt yourself on the ends of the wires.

1 START THE HEAD

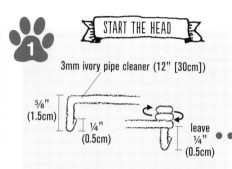

3mm ivory pipe cleaner (12" [30cm])

⅝" (1.5cm) ¼" (0.5cm) leave ¼" (0.5cm)

Bend the tip of the ivory pipe cleaner the ¼" (0.5cm), then bend it at ⅝" (1.5cm). Using the bent part as the core, wrap the pipe cleaner around the core two and a half times from the top down. Leave about ¼" (0.5cm) at the bottom.

2 MAKE THE EARS & NOSE

¼" (0.5cm) ¼" (0.5cm) ¼" (0.5cm)

twist

front ear coil 3 times

Bend as shown, then twist twice at the base of the ears. Wrap the pipe cleaner around to the back and push it through to the front. Coil it three times to make the lower half of the face. Insert the pipe cleaner into the center of the coil and pull it tight from behind, taking care not to pull too hard.

3

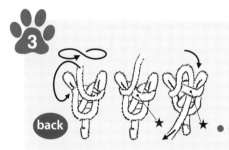

back

Turn the head around and wrap the pipe cleaner around the ears in a figure eight. Pass it under the diagonal portion (★) and pull it down.

4 MAKE THE TAIL

⅜" (1cm)

⅝" (1.5cm)

overlap by ⅝" (1.5cm) and twist

Bend the pipe cleaner coming out of the back of the head as shown. Twist the ⅜" (1cm) section to make the tail. Twist on another pipe cleaner at this point. Bring the pipe cleaner forward to the neck and wrap tightly twice. Include the core piece when wrapping.

5 MAKE THE LEGS & BODY

legs are ⅝" (1.5cm)

Make ⅝" (1.5cm) front and back legs. Wrap the pipe cleaner tightly from tail to neck and loosely from neck to tail to make the torso. Twist on another pipe cleaner at this point. Cut off any excess. See steps 11–18 p. 38 for how to make the legs and wrap the body.

6 ALL DONE!

glue pink fuzz inside ears

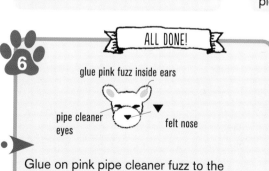

pipe cleaner eyes felt nose

Glue on pink pipe cleaner fuzz to the insides of the ears just like the adult dog on p. 74. Make eyes from black pipe cleaner and glue on. See the diagram to the right for how to make the eyes. Cut a felt triangle for the nose. Adjust the body shape, and you're done!

HOW TO MAKE PIPE CLEANER EYES

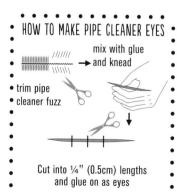

mix with glue and knead

- trim pipe cleaner fuzz

Cut into ¼" (0.5cm) lengths and glue on as eyes

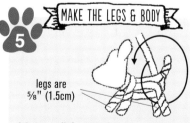

HOKKAIDO LONGMOGOL DOG

How to Make the Shiba

Model No. 71 (page 31)

Use two colors of pipe cleaner to make a two-tone classic Japanese Shiba dog.

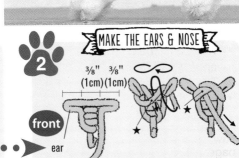

ACTUAL SIZE

MATERIALS

Model No. 71 (page 31)

- One 6mm white pipe cleaner, approx. 40" (1m)
- One 6mm copper pipe cleaner, approx. 40" (1m)
- Two 2.5mm toy eyes
- One 4.5mm bear nose
- Thick black thread for mouth
- Pink felt for tongue

How to Make the Other Model (page 31)

- Model No. 70

Make the same way as No. 71, using beige pipe cleaner for the head, ears, and back. Do not make a mouth or tongue.

All pipe cleaners used should be 40" (1m) long unless otherwise noted.

LONGMOGOL DOG SHIBA

START THE HEAD

1

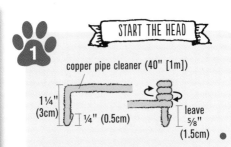

copper pipe cleaner (40" [1m])

1¼" (3cm) ¼" (0.5cm) leave 5⁄8" (1.5cm)

Bend the tip of the copper pipe cleaner ¼" (0.5cm), then bend it at 1¼" (3cm). Using the bent part as the core, wrap the pipe cleaner around the core three and a half times from the top down. Leave about 5⁄8" (1.5cm) at the bottom.

MAKE THE EARS & NOSE

2

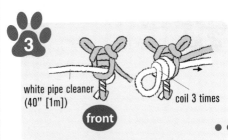

3⁄8" 3⁄8" (1cm)(1cm)

front ear

Bend as shown, then twist twice at the base of the ears. Wrap the pipe cleaner around to the back and wrap it around the ears in a figure eight. Pass the pipe cleaner under the diagonal portion (★) and pull it down.

3

white pipe cleaner (40" [1m]) coil 3 times

front

Cut ¼" (0.5cm) of the white pipe cleaner to use for eyebrows later. Insert the white pipe cleaner at the bottom of the front of the head and twist it together with the copper head core. Coil the white pipe cleaner three times to make the nose, then insert it into the center of the coil and pull it tight from behind, taking care not to pull too hard.

MAKE THE TAIL

4

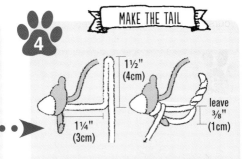

1½" (4cm) leave 3⁄8" (1cm)

1¼" (3cm)

Bend the white pipe cleaner coming out of the back of the head as shown. Twist the 1½" (4cm) section to make the tail. Bring the pipe cleaner forward to the neck and wrap tightly twice. Include the core piece when wrapping.

MAKE THE LEGS

5

legs are 1½" (4cm)

Make 1½" (4cm) front and back legs. Wrap the pipe cleaner tightly from tail to neck and from neck to tail to make the torso. See steps 11–18 p. 38 for how to make the legs and wrap the body.

MAKE THE BODY

6

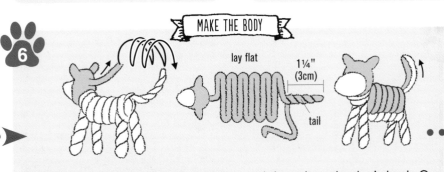

lay flat 1¼" (3cm) tail

Bend the copper pipe cleaner as shown and drape it on the dog's back. Once you reach the tail end, twist it as shown to make the second part of the tail. Cut off any excess and apply some glue to the tip. Bend it together with the white pipe cleaner so that they stick together into one curved tail.

How to Make the Shiba Puppy

Model No. 72 (page 31)

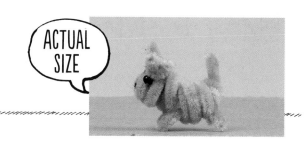

ACTUAL SIZE

Use 3mm pipe cleaner to make a little Shiba puppy.

MATERIALS

Model No. 72 (page 31)

- Three 3mm beige pipe cleaners, approx. 12" (30cm)
- Two 2.5mm toy eyes
- Black felt for nose

How to Make the Other Model (page 31)

- Model No. 69

Make the same way as No. 72, but make the eyes with a small piece of 6mm black pipe cleaner (see p. 75).

Use 12" (30cm) 3mm pipe cleaners for the puppies. Be careful not to hurt yourself on the ends of the wires.

1 · START THE HEAD

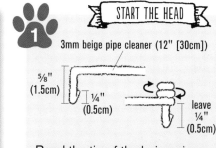

3mm beige pipe cleaner (12" [30cm])

⅝" (1.5cm) ¼" (0.5cm) leave ¼" (0.5cm)

Bend the tip of the beige pipe cleaner ¼" (0.5cm), then bend it at ⅝" (1.5cm). Using the bent part as the core, wrap the pipe cleaner around the core two and a half times from the top down. Leave about ¼" (0.5cm) at the bottom.

2 · MAKE THE EARS & NOSE

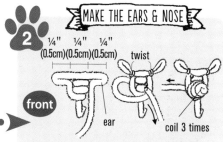

¼" (0.5cm) ¼" (0.5cm) ¼" (0.5cm) twist

front

ear coil 3 times

Bend as shown, then twist twice at the base of the ears. Wrap the pipe cleaner around to the back and push it through to the front. Coil it three times to make the lower half of the face. Insert the pipe cleaner into the center of the coil and pull it tight from behind, taking care not to pull too hard.

3

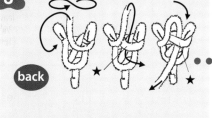

back

Turn the head around and wrap the pipe cleaner around the ears in a figure eight. Pass it under the diagonal portion (★) and pull it down.

4 · MAKE THE TAIL & LEGS

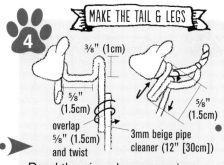

⅜" (1cm) ⅝" (1.5cm) ⅝" (1.5cm)

overlap ⅝" (1.5cm) and twist

3mm beige pipe cleaner (12" [30cm])

Bend the pipe cleaner coming out of the back of the head as shown. Twist the ⅜" (1cm) section to make the tail. Twist on another pipe cleaner at this point. Bring the pipe cleaner forward to the neck and wrap tightly twice. Make two ⅝" (1.5cm) front legs.

5 · MAKE THE BODY

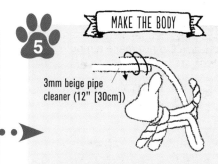

3mm beige pipe cleaner (12" [30cm])

Twist the front legs, then make two ⅝" (1.5cm) back legs. Twist on another pipe cleaner at this point, then wrap the torso tightly from tail to neck and from neck to tail. See steps 11–18 p. 38 for how to make the legs and wrap the body.

7 · ALL DONE!

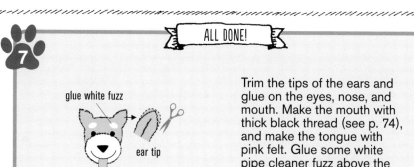

glue white fuzz

ear tip

Trim the tips of the ears and glue on the eyes, nose, and mouth. Make the mouth with thick black thread (see p. 74), and make the tongue with pink felt. Glue some white pipe cleaner fuzz above the eyes for eyebrows. Bend the tips of the legs slightly, adjust the body shape, and you're done!

6 · ALL DONE!

▼ felt

Glue on the eyes and felt nose. Adjust the body shape, and you're done!

How to Make the Papillon

Model No. 77 (page 33)

Papillon is French for "butterfly." Use a wavy pipe cleaner to express this feature.

ACTUAL SIZE

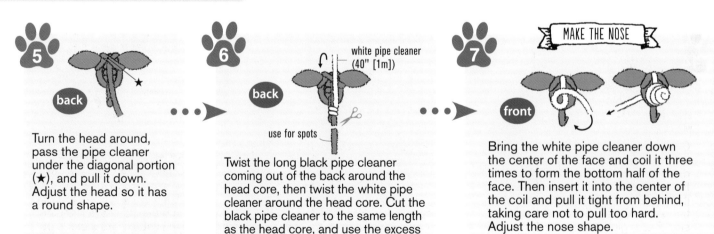

MATERIALS
Model No. 77 (page 33)
- One 6mm white pipe cleaner, approx. 40" (1m)
- One 6mm black pipe cleaner, approx. 12" (30cm)
- One black wavy pipe cleaner, approx. 12" (30cm)
- One white wavy pipe cleaner, approx. 12" (30cm)
- Two 3mm toy eyes
- One 4.5mm bear nose
- Pink felt for tongue

How to Make the Other Model
(page 33)

- Model No. 76
Make the same way as No. 77, using red brown pipe cleaner and red brown wavy pipe cleaner instead of black for the ears, head, and spots. Do not make a tongue.

All pipe cleaners used should be 40" (1m) long unless otherwise noted.

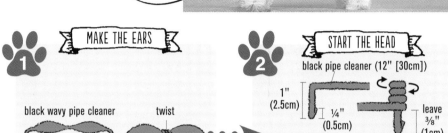

1 MAKE THE EARS

black wavy pipe cleaner twist

Bend the ends of four waves of black wavy pipe cleaner towards the center to make two fat fluffy waves, and twist the center.

2 START THE HEAD

black pipe cleaner (12" [30cm])

1" (2.5cm) ¼" (0.5cm) leave ⅜" (1cm)

Bend the tip of the black pipe cleaner ¼" (0.5cm), then bend it at 1" (2.5cm). Using the bent part as the core, wrap the pipe cleaner around the core three and a half times from the top down. Leave about ⅜" (1cm) at the bottom.

3

front

Bend as shown, bringing it around to the back and pushing it through at the top from back to front. Pull until there is no slack.

4 ATTACH THE EARS

in behind

front

Put the ears made in step 1 on top of the head, and tightly wrap the pipe cleaner twice around the center of the ears to hold them in place. Then wrap the pipe cleaner around the ears in a figure eight.

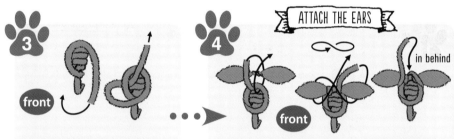

5

back

Turn the head around, pass the pipe cleaner under the diagonal portion (★), and pull it down. Adjust the head so it has a round shape.

6

back

white pipe cleaner (40" [1m])

use for spots

Twist the long black pipe cleaner coming out of the back around the head core, then twist the white pipe cleaner around the head core. Cut the black pipe cleaner to the same length as the head core, and use the excess for fuzz to make spots on the body.

7 MAKE THE NOSE

front

Bring the white pipe cleaner down the center of the face and coil it three times to form the bottom half of the face. Then insert it into the center of the coil and pull it tight from behind, taking care not to pull too hard. Adjust the nose shape.

Making Pipe Cleaner Pets

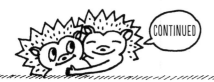

8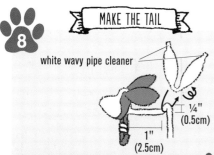

MAKE THE TAIL

white wavy pipe cleaner

¼" (0.5cm)

1" (2.5cm)

Bend the white pipe cleaner coming out of the back of the head as shown. Hook two waves of white wavy pipe cleaner onto the tail and twist them together at the base. Use needle-nose pliers to bend the tips of the wavy pipe cleaner inward so the wire isn't dangerous.

9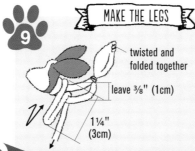

MAKE THE LEGS

twisted and folded together

leave ⅜" (1cm)

1¼" (3cm)

Bring the pipe cleaner forward to the neck and wrap tightly twice. Include the core piece when wrapping. Make a 1¼" (3cm) front leg, and pass the pipe cleaner through the torso to the other side.

10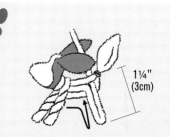

1¼" (3cm)

Make a second leg on the other side, then twist both front legs. Bring the pipe cleaner along the torso, make a 1¼" (3cm) back leg, and pass the pipe cleaner through the torso to the other side.

11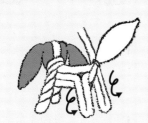

Make another leg on the other side, then twist both back legs.

12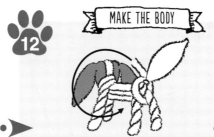

MAKE THE BODY

Pass the pipe cleaner over the tail and between the legs and wrap it tightly around the torso towards the neck.

13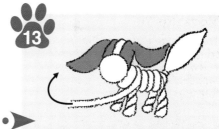

Wrap it loosely twice around the neck, then wrap the body again, moving towards the tail. Wrap loosely to create a fluffy look.

14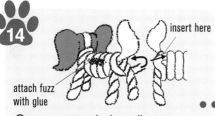

insert here

attach fuzz with glue

Once you reach the tail, pass the pipe cleaner over the tail and down through the legs. Bend the tip, apply a drop of glue, and insert it into the torso. Trim the fuzz off the piece of pipe cleaner cut in step 6 and glue it to the body to form spots.

15

ALL DONE!

adjust ears

felt

Plump up the black wavy pipe cleaner ears, glue on the nose, pink felt tongue, and eyes with painted eye whites. See the diagram at right for how to draw the eye whites. Bend the tips of the legs slightly, adjust the body shape, and you're done!

HOW TO PAINT EYE WHITES

fine-tip brush

eye

Use water-based enamel or dilute some acrylic paint with a tiny bit of water, and paint around the outside of a black toy eye with a very fine brush. It's easier to paint if the eye is stuck into a piece of sponge to hold it in place.

How to Make the Borzoi

Model No. 79 (page 34)

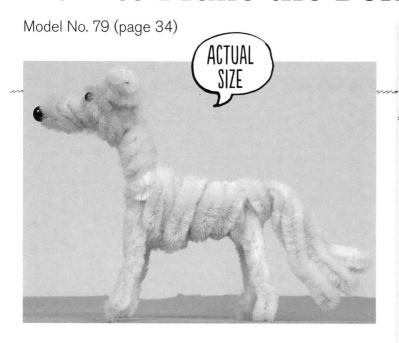

ACTUAL SIZE

MATERIALS
Model No. 79 (page 34)
- Two 6mm white pipe cleaners, approx. 40" (1m)
- Two 3mm toy eyes
- One 4.5mm toy eye for nose

How to Make the Other Model (page 34)

- **Model No. 78**
 - Two 6mm white pipe cleaners, approx. 40" (1m)
 - One copper pipe cleaner, approx. 40" (1m)

Cut the copper pipe cleaner to 12" (30cm) and refer to steps 2–3 p. 76 to make the head (make five coils for the nose). Use the white pipe cleaner coming out the back of the head to make the body the same as No. 79 from step 6. Cut another 12" (30cm) length of brown pipe cleaner, apply a drop of glue to the tip, and insert it into the back of the neck, then fold it in a zig-zag fashion to cover the back. Apply glue to the remaining tip and insert it into the torso.

All pipe cleaners used should be 40" (1m) long unless otherwise noted.

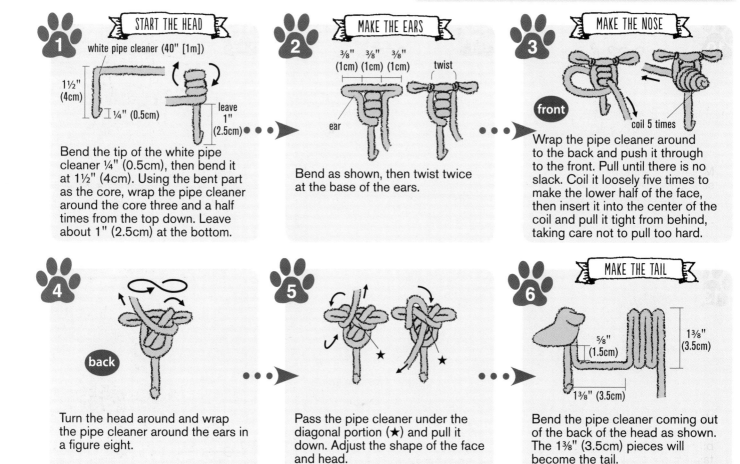

1 — START THE HEAD

white pipe cleaner (40" [1m])

1½" (4cm) — ¼" (0.5cm) — leave 1" (2.5cm)

Bend the tip of the white pipe cleaner ¼" (0.5cm), then bend it at 1½" (4cm). Using the bent part as the core, wrap the pipe cleaner around the core three and a half times from the top down. Leave about 1" (2.5cm) at the bottom.

2 — MAKE THE EARS

⅜" (1cm) ⅜" (1cm) ⅜" (1cm) twist

ear

Bend as shown, then twist twice at the base of the ears.

3 — MAKE THE NOSE

front coil 5 times

Wrap the pipe cleaner around to the back and push it through to the front. Pull until there is no slack. Coil it loosely five times to make the lower half of the face, then insert it into the center of the coil and pull it tight from behind, taking care not to pull too hard.

4

back

Turn the head around and wrap the pipe cleaner around the ears in a figure eight.

5

★ ★

Pass the pipe cleaner under the diagonal portion (★) and pull it down. Adjust the shape of the face and head.

6 — MAKE THE TAIL

⅝" (1.5cm) 1⅜" (3.5cm)

1⅜" (3.5cm)

Bend the pipe cleaner coming out of the back of the head as shown. The 1⅜" (3.5cm) pieces will become the tail.

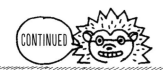

LONGMOGOLDDOG · BORZOI 102 · BORZOI

7 MAKE THE LEGS

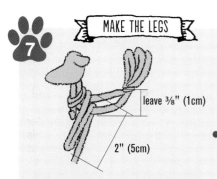

leave ⅜" (1cm)

2" (5cm)

Twist the base of the tail tightly two or three times. Bring the pipe cleaner forward to the neck and wrap tightly twice. Include the core piece when wrapping. Make a 2" (5cm) leg, and pass the pipe cleaner through the torso to the other side.

8

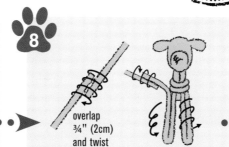

overlap ¾" (2cm) and twist

Twist on the other white pipe cleaner at this point. Make a second leg on the other side, and twist both front legs.

9

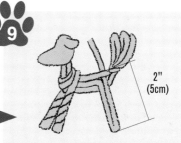

2" (5cm)

Bring the pipe cleaner along the torso to the tail, make a 2" (5cm) back leg, and pass the pipe cleaner through the torso to the other side.

10

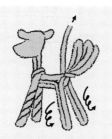

Make another leg on the other side, then twist both legs.

11 MAKE THE BODY

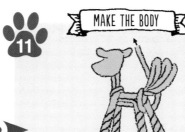

Pass the pipe cleaner over the tail and between the legs and wrap it tightly around the torso towards the neck.

12

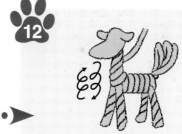

Once you reach the neck, wrap tightly up the neck to the head, then wrap loosely back down again.

13

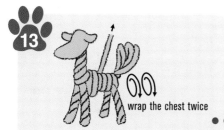

wrap the chest twice

Wrap twice around the chest to make it thicker, then wrap the body again, moving towards the tail. Wrap loosely to create a fluffy look.

14

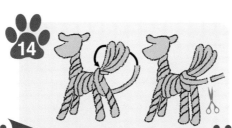

Once you reach the tail, pass the pipe cleaner over the tail and down through the legs, then wrap twice around the base of the tail. Cut off any excess, bend the tip of the pipe cleaner slightly, apply a drop of glue, and insert it into the base of the tail.

15 ALL DONE!

Glue on the eyes and nose. Bend the ends of the front and hind legs, adjust the body shape, and you're done!

Making Pipe Cleaner Pets

How to Make the Dalmatian

Model No. 80 (page 34)

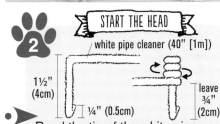

Use pipe cleaner fuzz glued to the body to give the dalmatian his distinctive spots.

MATERIALS
Model No. 80 (page 34)
- Two 6mm white pipe cleaners, approx. 40" (1m)
- One 6mm black pipe cleaner, approx. 12" (30cm)
- Two 3.5mm toy eyes
- One 4.5mm bear nose

How to Make the Other Model (page 34)

- Model No. 81

Make the same way as No. 80, but paint on eye whites (see p. 79).

All pipe cleaners used should be 40" (1m) long unless otherwise noted.

1 MAKE THE EARS

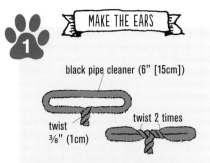

black pipe cleaner (6" [15cm])

twist 3/8" (1cm)

twist 2 times

Cut the black pipe cleaner in half, then bend it and twist as shown to make the ears. Use the remaining half to trim fuzz for the dog's spots.

2 START THE HEAD

white pipe cleaner (40" [1m])

1½" (4cm) ¼" (0.5cm) leave ¾" (2cm)

Bend the tip of the white pipe cleaner ¼" (0.5cm), then bend it at 1½" (4cm). Using the bent part as the core, wrap the pipe cleaner around the core three and a half times from the top down. Leave about ¾" (2cm) at the bottom.

3 MAKE THE HEAD

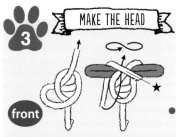

front

Bend as shown, pushing it through to the front and wrapping it around the ears made in step 1 in a figure eight. Pass the pipe cleaner under the diagonal portion (★) and pull it up.

4 MAKE THE NOSE

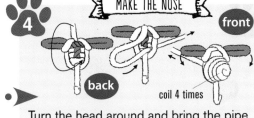

front

back

coil 4 times

Turn the head around and bring the pipe cleaner down the back of the head, then push it through to the front. Pull until there is no slack. Coil the pipe cleaner four times to make the lower half of the face, then insert it into the center of the coil and pull it tight from behind, taking care not to pull too hard.

5 MAKE THE TAIL

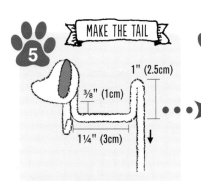

1" (2.5cm)

3/8" (1cm)

1¼" (3cm)

Bend the pipe cleaner coming out of the back of the head as shown. Twist the 1" (2.5cm) section to make the tail.

6 MAKE THE LEGS & BODY

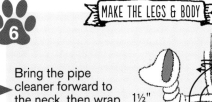

overlap ¾" (2cm) and twist

1½" (4cm)

Bring the pipe cleaner forward to the neck, then wrap it up and down the neck. Make four 1½" (4cm) legs. Twist on the second white pipe cleaner at this point. Take care to conceal the black pipe cleaner at the back of the head and to make the chest thicker. Cut off any excess. See steps 10–18 p. 38 for how to make the torso, legs, and body.

7 ALL DONE!

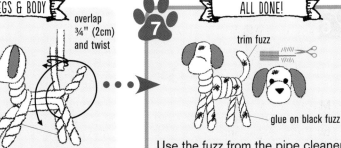

trim fuzz

glue on black fuzz

Use the fuzz from the pipe cleaner from step 1 to glue spots on the body. Glue on the eyes and nose. Bend the tips of the legs slightly, adjust the body shape, and you're done!

How to Make the Pug Puppy

Model No. 36 (page 20)

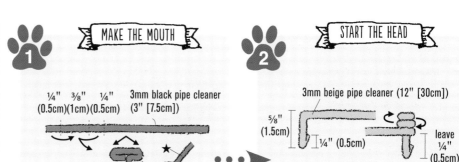

ACTUAL SIZE

Use 3mm pipe cleaner to make a pug puppy, a cute addition to the pug family.

MATERIALS
Model No. 36 (page 20)
- Two 3mm beige pipe cleaners, approx. 12" (30cm)
- One 3mm black pipe cleaner, approx. 12" (30cm)
- Two 3mm toy eyes
- Black felt for nose

How to Make the Other Model (page 20)

- Model No. 35

Make the same way as No. 36, using only black pipe cleaners. Glue on 11 small pearl beads as a collar.

1 MAKE THE MOUTH

¼" ⅜" ¼"
(0.5cm)(1cm)(0.5cm) 3mm black pipe cleaner (3" [7.5cm])

Cut a 3" (7.5cm) section of black pipe cleaner and bend it as shown. The portion marked with a ★ will be bent into ears after it is inserted into the head.

2 START THE HEAD

3mm beige pipe cleaner (12" [30cm])

⅝" (1.5cm) ¼" (0.5cm) leave ¼" (0.5cm)

Bend the tip of the beige pipe cleaner ¼" (0.5cm), then bend it at ⅝" (1.5cm). Using the bent part as the core, wrap the pipe cleaner around the core two and a half times from the top down. Leave about ¼" (0.5cm) at the bottom.

3

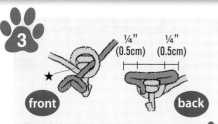

¼" (0.5cm) ¼" (0.5cm)

front back

Bend the beige pipe cleaner as shown, holding down the ★ while inserting the black mouth made in step 1. Turn the head around and use the remaining black pipe cleaner to make the ears. Again, hold the ★ portion while adjusting the shape.

4 MAKE THE HEAD

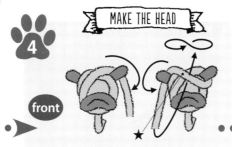

front

Turn the head back around to the front and wrap the beige pipe cleaner around the ears in a figure eight. Pass the pipe cleaner under the diagonal portion (★) and pull it tight from behind.

5 MAKE THE TAIL & LEGS

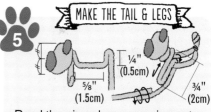

¼" (0.5cm) ⅝" (1.5cm) ¾" (2cm)

Bend the pipe cleaner coming out of the back of the head as shown. Twist the ¼" (0.5cm) section to make the tail. Bring the pipe cleaner forward to the neck and wrap tightly twice, make a ¾" (2cm) leg, and pass the pipe cleaner through the torso to the other side. Twist on the next pipe cleaner at this point.

6

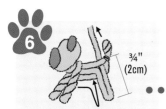

¾" (2cm)

Make a second leg on the other side, then twist both legs. Bring the pipe cleaner along the torso to the tail, make a ¾" (2cm) back leg, and pass the pipe cleaner through the torso to the other side.

7 MAKE THE BODY

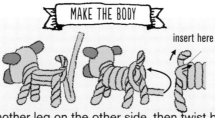

insert here

Make another leg on the other side, then twist both back legs. Pass the pipe cleaner over the tail and between the legs and wrap it tightly around the torso towards the neck. Wrap loosely once around the neck. Then wrap the body again, moving towards the tail. Wrap loosely to create a fluffy look. Once you reach the tail, pass the pipe cleaner over the tail and down through the legs. Cut off any excess, apply a drop of glue to the tip, and insert it into the torso.

8 ALL DONE!

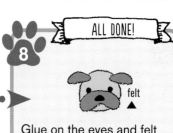

felt ▲

Glue on the eyes and felt nose. Adjust the body shape, and you're done!

How to Make the Boston Terrier Puppy

Model No. 17 (page 15)

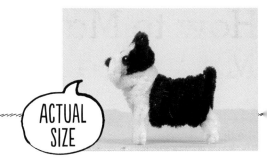

ACTUAL SIZE

Use 3mm pipe cleaner to make a cute puppy as part of a playful family.

MATERIALS
Model No. 17 (page 15)
- Two 3mm white pipe cleaners, approx. 12" (30cm)
- Two 3mm black pipe cleaners, approx. 12" (30cm)
- Two 3mm toy eyes
- Black felt for nose

Use 12" (30cm) 3mm pipe cleaners for the puppies. Be careful not to hurt yourself on the ends of the wires.

1 START THE HEAD

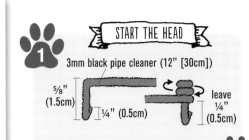

3mm black pipe cleaner (12" [30cm])

⅝" (1.5cm) ¼" (0.5cm) leave ¼" (0.5cm)

Bend the tip of the black pipe cleaner ¼" (0.5cm), then bend it at ⅝" (1.5cm). Using the bent part as the core, wrap the pipe cleaner around the core two and a half times from the top down. Leave about ¼" (0.5cm) at the bottom.

2 MAKE THE EARS

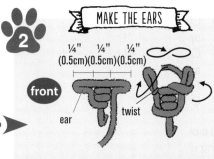

¼" ¼" ¼" (0.5cm)(0.5cm)(0.5cm)

front

ear twist

Bend as shown, then twist twice at the base of the ears. Bring the pipe cleaner around from the back and wrap it around the ears in a figure eight.

3

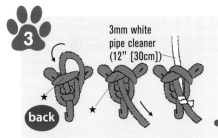

3mm white pipe cleaner (12" [30cm])

back

Turn the head around, pass the pipe cleaner under the diagonal portion (★), and pull it down. Insert the white pipe cleaner at the same spot and twist it together with the black one.

4 MAKE THE MOUTH

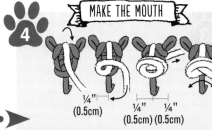

¼" (0.5cm) ¼" ¼" (0.5cm) (0.5cm)

Bring the white pipe cleaner down the center of the face and coil it twice for the lower half of the face. Insert the pipe cleaner into the center of the coil and pull it tight from behind, then bend the corners of the mouth down.

5

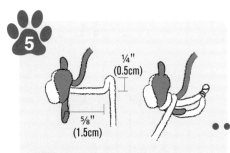

¼" (0.5cm)

⅝" (1.5cm)

Bend the pipe cleaner coming out of the back of the head as shown. Twist the ¼" (0.5cm) section to make the tail. Bring the pipe cleaner forward to the neck and wrap tightly twice. Include the core piece when wrapping.

6 MAKE THE LEGS

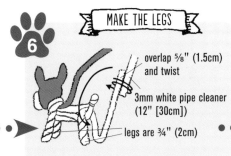

overlap ⅝" (1.5cm) and twist

3mm white pipe cleaner (12" [30cm])

legs are ¾" (2cm)

Make four ¾" (2cm) legs, then twist the legs. Twist on a second white pipe cleaner at this point. Pass the pipe cleaner over the tail and between the legs and wrap it tightly around the torso towards the neck.

7 MAKE THE BODY

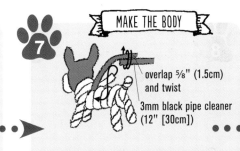

overlap ⅝" (1.5cm) and twist

3mm black pipe cleaner (12" [30cm])

Wrap it twice around the neck, cut off any excess, bend the tip slightly, apply a drop of glue, and insert it into the torso. Then twist on another black pipe cleaner to the black piece and wrap the body again, moving towards the tail. Wrap loosely to create a fluffy look.

LONGMOGOL DOG · BOSTON TERRIER

How to Make the Miniature Pinscher

Model No. 73 (page 32)

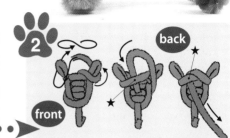

ACTUAL SIZE

The tip of the nose and the feet are a different color, black with a touch of brown for a dignified dog.

MATERIALS
Model No. 73 (page 32)
- One 6mm black pipe cleaner, approx. 40" (1m)
- One 6mm red brown pipe cleaner, approx. 40" (1m)
- Two 4mm toy eyes
- One 4.5mm toy eye for nose

All pipe cleaners used should be 40" (1m) long unless otherwise noted.

1

cut red brown pipe cleaner

nose (3" [8cm])

3/8" (1cm)

trim fuzz

four legs (1¾" [4.5cm])

Cut the red brown pipe cleaner into a 3" (8cm) piece for the nose and a 3/8" (1cm) piece for eyebrows and chest markings, then cut the remaining pipe cleaner into four 1¾" (4.5cm) pieces for the legs.

2

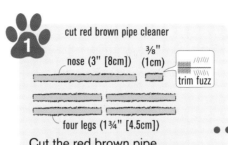

back

front

Follow steps 1–2 p. 86 to make the head and ears from black pipe cleaner, and wrap the pipe cleaner around the ears in a figure eight. Turn the head around, pass the pipe cleaner under the diagonal portion (★), and pull it down.

3

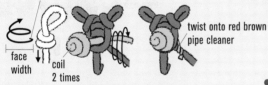

fold over ¼" (0.5cm)

face width

coil 2 times

twist onto red brown pipe cleaner

Bend the tip of the 3" (8cm) pipe cleaner ¼" (0.5cm), and make the nose as shown above. Insert the nose into the front of the face and twist it with the black pipe cleaner coming out of the back of the head. Make the body from the black pipe cleaner. See steps 5–6 p. 86 for measurements and instructions. Cut off any excess.

4

ALL DONE!

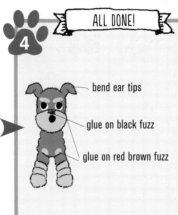

bend ear tips

glue on black fuzz

glue on red brown fuzz

Glue black pipe cleaner fuzz to the bridge of the nose. Use red brown pipe cleaner fuzz for the eyebrows and chest markings. Use the 1¾" (4.5cm) pieces of red brown pipe cleaner to wrap around the black legs. Glue on the nose and eyes with painted eye whites. See p. 79 for how to make the eye whites. Bend the tips of the ears, adjust the body, and you're done!

8

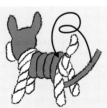

Once you reach the tail, bring the pipe cleaner up between the legs and wrap it around the tail, concealing the white pipe cleaner.

9

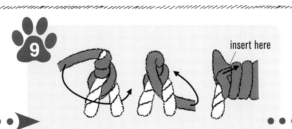

insert here

Pass it down through the back legs and bring it up to the torso, then cut off any excess, bend the tip slightly, apply a drop of glue, and insert it into the torso.

10

ALL DONE!

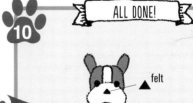

felt

Glue on the eyes and felt nose. Adjust the body shape, and you're done!

How to Make the Miniature Pinscher

Model No. 74 (page 32)

Bring out the pinscher characteristics with a long neck and pointed nose.

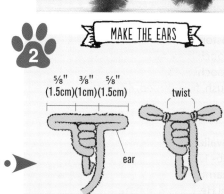

ACTUAL SIZE

MATERIALS
Model No. 74 (page 32)
- One 6mm red brown pipe cleaner, approx. 40" (1m)
- Two 3.5mm toy eyes
- One 4.5mm toy eyes for nose

How to Make the Other Model (page 32)

- Model No. 75

Make the same way as No. 74, but use 4mm toy eyes and paint on eye whites (see p. 79).

All pipe cleaners used should be 40" (1m) long unless otherwise noted.

1 START THE HEAD

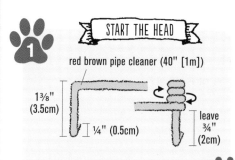

red brown pipe cleaner (40" [1m])

1³⁄₈" (3.5cm) ¼" (0.5cm) leave ¾" (2cm)

Bend the tip of the red brown pipe cleaner ¼" (0.5cm), then bend it at 1³⁄₈" (3.5cm). Using the bent part as the core, wrap the pipe cleaner around the core three and a half times from the top down. Leave about ¾" (2cm) at the bottom.

2 MAKE THE EARS

⁵⁄₈" ³⁄₈" ⁵⁄₈" (1.5cm)(1cm)(1.5cm) twist

ear

Bend as shown, then twist twice at the base of the ears.

3 MAKE THE NOSE

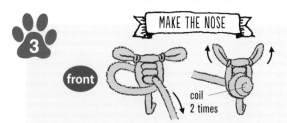

front coil 2 times

Wrap the pipe cleaner around to the back and push it through to the front. Pull until there is no slack. Coil the pipe cleaner loosely two times to make the lower half of the face. Insert the pipe cleaner into the center of the coil and pull it tight from behind, taking care not to pull too hard. Shape the nose to make it slightly pointed.

4

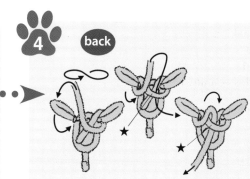

back

Turn the head around and wrap the pipe cleaner around the ears in a figure eight. Pass it under the diagonal portion (★) and pull it down.

5 MAKE THE TAIL & LEGS

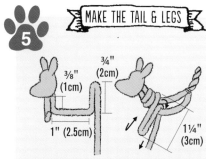

³⁄₈" (1cm) ¾" (2cm) 1" (2.5cm) 1¼" (3cm)

Bend the pipe cleaner coming out of the back of the head as shown. Twist the ¾" (2cm) section to make the tail. Bring the pipe cleaner forward to the neck and wrap tightly twice. Make two 1¼" (3cm) front legs, then twist both legs. See steps 11–18 p. 38 for how to make the legs and torso.

6 MAKE THE BODY

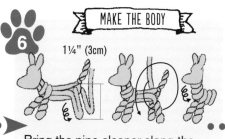

1¼" (3cm)

Bring the pipe cleaner along the torso to the tail and make two 1¼" (3cm) back legs. Pass the pipe cleaner over the tail and between the legs and wrap it tightly around the torso towards the neck. Then wrap upwards once on the neck and downwards three times on the neck. Wrap the body again, moving towards the tail. Wrap loosely to create a fluffy look.

7 ALL DONE!

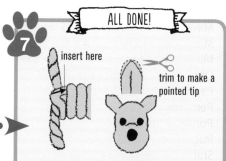

insert here trim to make a pointed tip

Once you reach the tail, bend the tip of the pipe cleaner, apply a drop of glue, and insert it into the torso. Trim the tips of the ears, glue on the eyes and nose, bend the tips of the legs, adjust the body shape, and you're done!

Making Pipe Cleaner Pets

Index

More Great Books from Design Originals

Parachute Cord Craft
ISBN 978-1-57421-371-3 **$9.99**
DO3495

Plastic Lace Crafts for Beginners
ISBN 978-1-57421-367-6 **$8.99**
DO3490

Halloween Plastic Lace Crafts
ISBN 978-1-57421-383-6 **$8.99**
DO3506

Felt from the Heart
ISBN 978-1-57421-365-2 **$9.99**
DO3488

Bead Weaving on a Loom
ISBN 978-1-57421-384-3 **$8.99**
DO3507

Making Jewelry with T-Shirt Yarn
ISBN 978-1-57421-374-4 **$8.99**
DO3498

Sew Fun for Girls & Dolls
ISBN 978-1-57421-364-5 **$11.99**
DO3487

Making Jewelry with a French Knitter
ISBN 978-1-57421-363-8 **$8.99**
DO3486

Awesome Foam Craft
ISBN 978-1-57421-352-2 **$9.99**
DO3475

Look for These Books at Your Local Bookstore or Specialty Retailer or at *www.d-originals.com*